O Say Can You See

O SAY CAN YOU SEE

AMERICAN PHOTOGRAPHS. 1839-1939

*One Hundred Years of American Photographs
from the George R. Rinhart Collection*

◆

Thomas Weston Fels

Preface by George R. Rinhart

Foreword by Debra Bricker Balken

◆

THE BERKSHIRE MUSEUM

THE MIT PRESS
Cambridge, Massachusetts
London, England

Printed and bound in the United States of America

Library of Congress Cataloging-in-Publication Data:

Fels, Thomas Weston.
 O say can you see: American photographs, 1839-1939: one hundred years of American photography from the George R. Rinhart collection / Thomas Weston Fels: preface by George R. Rinhart; foreword by Debra Bricker Balken.
 144 pp. 22.8 x 30.6 cm.
 Bibliography: p. 139
 Includes index.
 ISBN 0-262-06120-1
 1. Photography, Artistic—Exhibitions. 2. Photography—United States—Exhibitions. 3. Rinhart, George R.—Photograph collections—Catalogs. 4. Berkshire Museum—Catalogs. I. Title. II. Title: George R. Rinhart collection.
TR646.U6P584 1989
779'.0973'07401441—dc19 88-35970
 CIP

This book produced in conjunction with the exhibition:

O SAY CAN YOU SEE
American Photographs, 1839-1939;

One Hundred Years of American Photography from the George R. Rinhart Collection

assembled by
The Berkshire Museum
Pittsfield, MA 01201

Installation dates:
The Berkshire Museum: April 8-June 17, 1989
Bowdoin College Museum of Art: October 12-December 12, 1989

Dust jacket design by George R. Rinhart.

This book has been designed by Jonathon Nix and printed by The Studley Press, Dalton, Massachusetts, in a hardbound edition of 3,000 copies, April, 1989.

This exhibition has been funded in part by The Berkshire Eagle and General Electric Company and with assistance from The Barrington Foundation, Inc.

CONTENTS

6

Foreword
Debra Bricker Balken, Curator of Art, The Berkshire Museum

7

Preface
George R. Rinhart

9

American Photography: Opportunities and Images
Thomas Weston Fels, Guest Curator

22

Plates

123

Biographies of Photographers/Notes on the Photographs

137

Notes

139

Bibliography

141

Index

FOREWORD

THIS EXHIBITION DRAWS ATTENTION TO ONE OF THE PRE-
eminent assemblages of photography formed by an individual. George
Rinhart's collection, which was begun in 1960 when he was sixteen
years of age, is remarkable not only for its scale and breadth but for its
high quality. Many of the images highlighted here are exceedingly
rare, some are one of a kind. They have been sought after and selected
by a mind which is highly curious about American history and the
images which survive to document this country's past. This curiosity
has led George Rinhart beyond attachment to the foremost figures
associated with American photography to consideration and recogni-
tion of lesser-known photographers whose work has been over-
shadowed by mainstream developments. Therein lies the richness,
variety and singularity of his collection.

It is an honour for The Berkshire Museum to be the only institution
to organize an exhibition derived solely from this collection. I have
more than enjoyed working with George Rinhart on this project and
am most appreciative of the opportunity he has presented us.

Exhibitions by nature are never realized singlehandedly. Many
individuals contributed to the making of this project. In particular, I
am very grateful to Francis DiMauro for the important role he played
in the research of this exhibition, as well as for his input into its
organization. Thomas Fels, guest curator, has come up with a fresh
take on American photography and its location within the context of
national history and western culture. For his interpretation of the
collection, I am thankful.

I am very pleased that this exhibition will travel to The Bowdoin
College Museum of Art after its installation at The Berkshire Museum.

Lastly, I would like to note the generous support of the exhibition's
funders. My gratitude is extended to The Berkshire Eagle, General
Electric Company and The Barrington Foundation, Inc.

DEBRA BRICKER BALKEN
Curator of Art
The Berkshire Museum

PREFACE

AMERICAN HISTORY HAS ALWAYS HELD AN ENORMOUS fascination for me. Our independence, our individualistic approach to virtually everything stood us apart, both as a people and as a nation. Eighteen thirty-nine marked the fiftieth anniversary of the inauguration of George Washington as President. It was also the year of the birth of photography.

In the period from 1839 to 1939, America underwent enormous changes, good and bad, always momentous. We experienced the growth of industry, the westward expansion, social and political turmoil, the Civil War, the Golden Age of capitalism, immigration, innocence, and with World War I, a global role.

During this entire period, innovative and creative men and women were there with their cameras. They photographed the rich and famous, the common man, the wars, and the face of America from the Atlantic to the Pacific. In my collecting, I have tried for nearly thirty years to find the best photographs of and about America.

The photographs in this book are my vision of the American scene during that tumultuous period in our history. Much has been left out. It is difficult to choose one hundred photographs to represent such an era.

One of the great things about photography is the finding of new images or rediscovering long lost "known" images. The joy of the hunt and the discovery of these American photographs is really indescribable. I know of no other field of collecting in which such extraordinary discoveries can be made. I am delighted to share my aesthetic pleasure in discovering the two Samuel Masury photographs or my sense of the roles of Harriet Beecher Stowe and John Greenleaf Whittier in fighting slavery. To me, these images show them at their determined best.

I hope you will enjoy looking at these photographs as much as I have enjoyed collecting them. They have expanded my vision of America and of the role photography has played in that vision.

If this book has helped you to *see* photographs in a different light, then it has been more than worth the effort.

GEORGE R. RINHART
Colebrook, Connecticut

Believe me, my friends, that
Shakespeares are this day being
born on the banks of the Ohio.
And the day will come, when you
shall say who reads a book by an
Englishman that is a modern?

HERMAN MELVILLE
Hawthorne and His Mosses, 1850

AMERICAN PHOTOGRAPHY: OPPORTUNITIES AND IMAGES

The George R. Rinhart Collection in Context

THE HISTORY OF PHOTOGRAPHY IS THE ART HISTORY OF OUR era. It is a history in which photography in America plays a crucial role. The American cultural presence is the dominant one of the past hundred years. If we accept the accompanying implications, we will see that it is to the arts which have fostered the success of American culture that we must turn in our search for the roots of the art history of our time.

These roots are not what we might expect. In the tradition of Western art which we encounter in our great museums and in our travel, portraits served as records of personality and social stature; altarpieces signified devotion and means. Immense tableaux were devoted to the most fleeting moments of psychology, and months might be spent in recreating a brief passage in history. In this way, the fine arts of painting and sculpture were novelistic in scope, expressing important aspects of the inner life of their culture in the best medium, and the most compelling form, available.

If in our own time we seek the most expressive, characteristic, powerful art, we must look not simply for more paintings and sculpture, but for the similarly strong aspects of our own arts, areas where energy is applied, and creativity supported, where effects are produced by the work, and in which the imagination of its makers reflect the most important currents in our cultural life. In the visual arts, this line of inquiry does not lead us to the traditional media, but to the popular arts, and especially to photography. For, in contemporary America, the success of the visual image is tied characteristically not to painting or sculpture, but to the photograph, the news magazine and rotogravure, to film and lately to television—in short to the medium announced in 1839, which through its important role in American culture has helped to transform the world.

The crucial importance of American photography has been little noticed because the full significance of American culture has yet to be appreciated. If we look back on the history of the past century and a

half, American figures and events from the early days of photography still appear to many to have a parochial cast. The spectacles of Barnum, the poetry of Whitman, the journalism of Horace Greeley, the sermons of Henry Ward Beecher still seem more American than universal; they are all identified more with our own history than with that of the world. But this view changes if we consider our history in a different light. The philosophies of Emerson and Thoreau, both of whose careers also coincided with the introduction and growth of the medium, have had strong influence on the world's thinkers. Lincoln, a central fixture in our national mythology, and a historical figure of international significance, is perhaps the first of such importance whose image is inextricably tied to the photograph. The Civil War was an important testing ground not only for social and political principles, but for the photographic reporting of news. Such photographs of American men and women, and of the events in which they played a part, have not only helped us to picture our own past, but have become the standard for others as well. The completion of the railroads and the geographical exploration of the West, further examples which followed the Civil War, were not only monumental feats of science and engineering, but through photography, with some assistance from literature and art, played a key role in the development of the American imagery which now surrounds us every day.

One could cite a number of other examples. What they serve to reveal is that in America, photography and culture grew up together. The heights of its art reflect important aspects of its history: records of its personalities and public figures, scenes of its great wars, the progress of its industries, the exploration of its land. To an important degree, the development of this medium which has been so influential, and which now bears in basic ways a characteristic American stamp, is a reflection of the opportunities afforded its use in the course of the growth of the culture. The two, then, are mixed in a way which irrevocably affects them both.

This enactment of history in art is not a new phenomenon. One way of seeing American photography in larger perspective is to note in it the presence of the lawmakers, generals, orators, and poets, the battles and beauties who have always been among the favored subjects of art. The record provided by American photography is of a new

◆

society, but the similarity of the medium to its predecessors as a document and an art is clear. If it is the patrician motives of the Old World that speak most frequently in its best known art, images of American photography speak most clearly of the democracy whose workings they embody. The history of photography in America is the history of a new and powerful means through which burdens of choice and responsibility were exercised by the public. As a new source of power, influence, and expression, it took its place among other innovations of technology to implement the tenets of a new social order. The cast of characters and events which fill our photographs of the past hundred and fifty years, while American, are figures in a past that is now a crucial chapter in the early history of the modern world, a world we have in important ways helped to shape.

Many of both the triumphs and weaknesses which we owe to democracy in our age are tied in some way to photography. Unlike painting and literature, photography had no previous history or established value. Its continued existence depended entirely on its acceptance, and on the ability of new professions—the daguerrean, and later the photographer, periodical publisher, and filmmaker—to make a living by its use. By charting that use we begin to see that, much as European art reflects its own culture, the photograph reveals from the beginning the visual language of the important modern creed whose first success preceded it by only fifty years. If Washington is best represented by Gilbert Stuart, and we look to marble and coins for images of the Caesars, after Lincoln for images of democracy we turn to the photograph.[1]

Despite the importance of these developments, they have been little recognized. They have been acted upon even less. Although serious efforts have been made by some repositories and museums to treat the American photographic patrimony with the care it deserves, these efforts have been typically under constraints of budget and staff which limit their effectiveness to an enormous degree. The priceless negatives of Mathew Brady, perhaps the most pivotal single body of work in the recent social and artistic history of the nation, languished for years, changing hands several times among publishers who reproduced them for profit; their purchase was at one point turned down

◆

even by Congress. In their long and difficult history, numerous pieces have been broken or lost.[2] Throughout the country other large bodies of work lie unused, and important work unrecognized, for lack of adequate scholarship or available means.

For this reason Mr. Rinhart's efforts in American photography over the past twenty-five years take on a special significance. In a field of art history still in the process of formation, the role of locating and collecting works has an important historical and scholarly place; with an art as fragile as that of the photograph, it has the additional value of guarding the physical safety of the works. In combination, what Mr. Rinhart has achieved, and is still achieving, through his collecting is nothing less than the retrieval from almost certain obscurity of an important part of the overall oeuvre of American photography. Through this work he has secured for future generations an important portion of the store from which our impression of the whole will eventually be drawn.

In the course of these efforts, the preservation of American photographs has become something of a personal mission. Mr. Rinhart has taken on many of the responsibilities associated with larger institutions. Through his extensive searches for photographs and his ongoing research into the lives and work of photographers, he has developed a highly educated sense of the field of American photography, which guides him in his work. In an area of study too young to have developed many scholarly tools, the necessary accumulation and consultation of primary sources—photography magazines, records of exhibitions, letters, and archives—has become a major activity in itself. His home is devoted in large measure to a research library assembled to aid his collecting. Through his work with photographs and archival resources he has fashioned his own map of the field from which he operates, judging for himself the relative value or importance of the works he encounters.

Considering the vagaries of history, it might appear that in such a search it is merely a matter of chance as to what is found, and of necessity as to what deserves attention; this is far from being the case. A great deal of choice and decision making is involved. It will be no surprise that when a rare image of Harriet Beecher Stowe (24) should appear at a small rural sale, Mr. Rinhart would be able to recognize it

◆

for what it is. But how does he happen to be at the sale? It seems natural that he should track down one of the earliest photographic collections in America (31,32,33), but how was he aware that it still existed or where it was? The presence of important prints of Kasebier, Archer, or Rothstein (80,31,121), of a unique image of Stieglitz (91), or a fine, characteristic piece from the work of an otherwise forgotten photographer (122) may appear merely to argue for Mr. Rinhart's taste; they also reveal his attention to the building of a canon of American work. Often he will turn down a more expensive and, by conventional standards, desirable work for one which is unknown and seems to be of little value; it is usually the work he selects which turns out to be the important one.

In Mr. Rinhart we see the classic marks of the collector. Along the way, he has provided crucial threads with which we may be able to reweave important sections of the fabric of the history of photography in America. Since he has undertaken the work of research and discovery that few others have, the results of his judgments may well prove to be central to future assessments of the medium.

Much of this is apparent in the current selection. In looking through Mr. Rinhart's collection with the purpose of assembling an exhibition and a book, the intention to represent American photography over a hundred year period was aided both by his interest in American history and the inevitability of its appearance in any broad selection of American work. Thus, the distinct sections into which the works fall unavoidably echo both historical and artistic categories. The opening chapter of American photography begins in Philadelphia, Boston, and New York, where the medium takes up concerns of the art of its day. It is focused largely on portraiture, and the works selected here from this era emphasize the political current of abolitionism as well. This is of importance because it is the confluence of history and art which is to be characteristic of American photography up to the present; here we can see that its origins lie at the very beginning of the introduction of the new medium to this country.

The portraits of abolitionists shown here are among the most moving of early American daguerreotypes. They are not only wonderful examples of the early art of photography in this country, they are a

◆

direct source of evidence about those who figured in the central national issue of their time. It is worthy enough of note that the subject of one of the finest early daguerreotypes is a black man; this gains considerable depth when seen in the context of his peers. James Forten (23) was a founder of Garrison's *Liberator*, in 1831; the poet John Greenleaf Whittier (26), an important portion of whose career was based on abolitionism, was a protégé of Garrison; both Whittier and Charles Calistus Burleigh (25) were editors of the abolitionist *Pennsylvania Freeman*. General Hitchcock (30) was an abolitionist as well; Stowe's (24) *Uncle Tom's Cabin* is of course well known. An unusual daguerreotype button displaying abolitionist imagery (27) completes a brief survey in which works from the earliest period of American photography are drawn from a crucial chapter in its history.

Numerous daguerreotypes, some of the present examples among them, were copied as engravings, paintings, or lithographs, but without the originals how would we know the powerful reserve of Forten, the willowy youthfulness of Stowe, the burning determination of Burleigh which we can read in the face of the photographic image? Certainly the early portrait of Whittier, which is shown here in its original form for the first time in more than half a century, adds an important and immeasurable element of depth to written descriptions of the poet, one of whose contemporaries described him at an abolitionist meeting in 1833 much as he appears here some ten years later. With his stiff collar, black whiskers and flashing eyes giving him "as much of a military as a Quaker aspect," his chiseled forehead and features adding to his image as a poet and public figure, this daguerreotype gives us a very clear picture of why even at an early age Whittier might have been "quite a noticeable feature" at the convention.[3]

Of course, one might say that the history of America is not merely the history of its faces. But to a remarkable extent, in art, it is precisely human character, and the representation of human events and thoughts, which are deemed important. Often in history, and in the history of art, it is to faces that we turn for points of reference concerning individuals and events, as well as for clues to the personality of the depicting artist himself. It is largely to this habit of searching out physical veracity that the introduction of photography owes its

◆

impact. For the truth of these faces, and the change it brought to expectations in visual representation, constituted a force which could not be avoided. Thus it is not only these earliest portraits which have been included here; the only slightly later ones of the historically related figures John Fremont (35), James Buchanan (36), and Jeremiah Black (37), as well as a group of important poets (38), continue the tradition of portraiture into the era of the new wet plate negative and salted paper print which was to transform photography from a private medium in which the object was considered by an individual in its diminutive case, to one in which images became to some degree public through reproducibility as paper prints. Beyond these, those of Andrew Johnson (45), Edward Everett Hale, (46) and a selection of the numerous photographs taken by Brady and others at the time of the Civil War continues the wet plate era into the long reign of the albumen print, which lasted, alongside the many further developments in photography, into the early years of the twentieth century.

Two British photographs have been included in this hundred year selection; both were chosen because of their influence on American work. The first of these is *Self-portrait, Kenilworth*, by Frederick Scott Archer (31), which separates the era of the daguerreotype from that of the wet plate, which Archer invented. Although a more complicated process than those of either the earlier daguerreotype or calotype, both dating in their official form from 1839, the new wet plate, with its cumbersome equipment and delicate technique, introduced in 1851, combined the detail captured by the first with the ease of reproduction of the second to offer a medium far more responsive to the needs of both the photographer and his public.

It would be difficult to underestimate the importance of Archer's invention.[4] An entire era of American photography, the era which in many ways first publicly defined its primary tradition and set its tone for the future, was dependent on this new method. For Mathew Brady (41), Alexander Gardner (40), Timothy O'Sullivan, and other photographers of the Civil War, the technical advances provided by the advent of the wet plate significantly expanded the aesthetic range and visual impact of photographic work; its reproducibility, enabling the public to participate in the life of these images through display, or collection in

◆

bound albums, or use of a stereoscope, created the potential for the large market which developed for prints, a market which in turn spawned a greatly enlarged industry for the photographing, printing, selling, and distributing of pictures. Since photographs, unlike paintings, were affordable, the recording and dissemination of photographic images of the Civil War became the first victory on a public scale for a truly democratic art. It differed from the early rage for portraiture, which began with the daguerreotype, not in its dependence on the photograph or the involvement of individuals, whose importance was already proven—for portraiture continued to be highly popular throughout the course of the war—but in the new ability of the wet plate to satisfy a need for communication on a large scale. This activity supported the existence of the large photographic organizations which had been formed or expanded by such entrepreneurs as Mathew Brady and the E. and H.T. Anthony Company, which were to become models for future photographic work in the larger publications and photoagencies that characterize the modern era.

A further outgrowth of the wet plate was American work in the Far West following the Civil War. Just as numerous early figures such as George Barnard (1819-1902) and Samuel Masury (32,33) formed a link from daguerrean to wet plate work, so several important photographers of the Civil War joined the ranks of their professional peers to open a new chapter in the life of the medium by documenting the development of the West. Among the best were Gardner (48,49), O'Sullivan (53,56), and William Bell (52). In part because of their extensive previous experience, in part because of their sheer ability, and in part due to the extraordinary opportunity offered by the work, the value of their contribution is now considered inestimable.

Much has been written about nineteenth century photography in the Far West; there is certainly a good deal more to be said. In setting a context for American photography and the George R. Rinhart Collection, the most essential observation is that of the confluence of the development of the medium of photography with that of the discovery and iconization of American land. American photography is unique in its sustained application of a growing, changing medium at its core entirely new, to land and life which itself had never been seen before. Exploration, development, settlement, building, industry, and cultural

◆

life became central subjects in the medium; the resulting union affected communication and art for the succeeding century. The parallels usually drawn in setting out the development of American photography relate it to its sister cultures in Europe. But, recognition of the new global culture that characterizes our time suggests that the proper nineteenth and early twentieth century comparisons are probably to be sought rather in other lands new to the Western eye, where similar patterns of transcontinental development forged a marriage of the new art of photography with the unfamiliar subjects encountered. In our own time, the similarity of earlier work in the Far West to that of our new explorers in space would seem to be clear enough to require little further elaboration.

The photographers of the Far West, who like Brady, developed an entire industry in the production and selling of images, are in large measure responsible for our visual picture of that time, although to a remarkable degree, the written literature and documents of the period form quite an accurate parallel to its photographs. In the work of Watkins (51,57), Jackson (55), Savage (54), and others we encounter the great mountains and tiny towns, the advancing railroads and mouldering Indian relics of the West as it was described by Mark Twain, Ambrose Bierce, and Bayard Taylor. Wet plate activity in the East, as well as in other areas in which exploration was conducted, if perhaps not often as striking or novel, was equally accomplished (58,60,61,64). For both, the documentary quality of the work eventually extended first to the opening field of photojournalism, and later to the documentary style both in government work during the Depression (121) and in the socially and industrially oriented work of art photographers like Weston, Bratter (106,107), and Bruehl (120) beginning in the early twentieth century.

What is perhaps missing from most descriptions of the photographers of the wet plate era in the West is, ironically, one of the most obvious: they are printmakers. In the lengthy descriptions of their heavy glass plates and volatile chemicals, of mule trains filing through steep passes, of specially outfitted railroad cars, and cameras backpacked up the sides of mountains that fill the literature on the subject, it is often forgotten that this simply represents the necessary equipment of the time. What is remarkable is not the effort, for heroic efforts

◆

seems to have been the order of the day; it is the strength of the desire to produce photographic prints. For a printmaker to bring his entire platemaking operation to a mountain top; to prepare the glass plate, mix chemicals, and calculate an exposure in order to receive directly the image-making light; to work in sand and snow and in the gritty dust of mining towns, to adapt the necessary processes to the different weather and geography he might encounter—these represent major changes in the age old pursuit of making reproducible images.

As a form of printmaking, these changes must be considered radical indeed. Their effect on graphic art parallels that of plein-air work in painting: the results they produced were entirely different from earlier work. The new habits engendered in pursuing the work affected both the content and the style of its products. As with Impressionism, the wet plate photographers in the West produced art which reflected the new knowledge of their day. As painting would no longer be the same after the formal recognition of the surface fragmentation of light, so the art of the printed image was changed forever by a new technology which reproduced what the artist saw in the visual language of photography. That the wet plate photographers in the West were artists who recognized this, and not technicians or explorers who happened to be in the business of taking pictures, is a distinction which lends important meaning and weight to their work.

The amateur movement which constitutes the next major change in American photography was focused on printmaking as well, although its apparent cause was a change in the manufacture of cameras. While wet plate, and later dry plate amateurs existed, the introduction of the small, hand-held camera changed the developing field of photography from one dominated by professionals to one in which amateurs could play a significant role. Beginning in the eighteen eighties, with some notable exceptions, professional work became generally less strong and amateur work more so. There were also many cases of individual photographers, among them Kasebier (75,80,82,83) and Spencer (73), whose adoption of the medium as both vocation and avocation put them in the professional and amateur camps at once. The advent of the hand-held camera, and of other technical advances such as roll film and commercial developing which made the field more easily accessible, lent itself to the possibility of trivializing subject matter, loosening

◆

the stringency of composition, and lowering technical standards. As with the introduction of modern improvements in numerous other fields, this stage of photographic history seemed only to prove that it was possible to do less with more.

The reaction to this among serious photographers bent on producing art was the revival, and new development, of techniques which emphasized the uniqueness of the individual artist and print. In the face of a growing homogeneity, the number of styles, products, and techniques by which one could vary the basic enterprise of photography expanded seemingly exponentially. A look at the works from this period, the largest group in the current selection, and an area of particular strength in the George R. Rinhart Collection, amply demonstrates this. From about 1880 on into the nineteen twenties (beginning here with William Willis's original Platinotype of 1878 (72), the second British photograph in the current selection), we find hardly two prints which look alike. Louis Comfort Tiffany (97) and Ema Spencer (73) use the cyanotype process, a simple but durable survival from the early days of the medium, and the writer and illustrator Clifton Johnson (81) employs albumen paper in 1895, near the end of the period of its common use, while their contemporaries are printing with the newer platinum and gum. Colors range from the fixed blue of the cyanotype to the varied colors of ink used in the popular gum process. At this period an entire range of greys, browns, and yellows is represented; even blacks take on numerous subtleties: *The Mill at Ipswich*, by Coburn or Underwood (76), has a distinctly greenish cast. Latimer's *Ferryboat* (94) has a Whistlerian, nineteenth century flavor, whose flatness is reminiscent of a Japanese print, while in the same period others appear to be under the influence of the lively new European Expressionism. Perhaps the only common strand visible is the familiar soft grey of platinum.

This vast variety may have helped to fortify the artistic soul in an era haunted by the ghost of reproduction, but it also set the basic poles of the prevailing dialectic for the succeeding years of the medium. For, tiring of prints they had come to feel were merely tarted up, photographers soon swung back in the other direction. Returning to the example of the Civil War work of Brady, Gardner, and O'Sullivan, to the more recent documentary work of Riis and Hine, and the early

◆

photojournalism of the news services (65) and of reporters like Jimmy Hare (62,68), they revived a photography that was devoid of the trappings of the painting-related art the printmakers had so earnestly sought. This too, ironically, was a result of new technical developments and habits, for creative reinterpretation of the "lowered" standards of the art brought on by amateurs, photojournalists, and documentrians produced a new view, again parallel to developments in painting, in which the accidents and exigencies of the new styles came to be valued as breaks from tradition, putting in a positive light photographic conventions which at first had been seen as negative.

Photography had in this period also become considerably more sophisticated. From the first, the medium had produced works of unsurpassed quality and artists of great sensitivity and ability. But, by the late nineteenth century, American culture had expanded enough to accommodate a wider range of personal and artistic interests, and had developed new sets of social and economic needs, all of which might be served by photography. The advent of Modernism, which succeeded and to some extent overlapped the amateur movement, revealed the influence of Americans' involvement with European artists and salons. Their familiarity with the aesthetic currents of the day reflected the increased ease of travel and communication. They were no longer isolated; they began to emerge as leaders and not followers; their photographic work began to take on a toughness and versatility that suited the many new facets of their culture. In the work of the twenties and thirties we find a variety more of purpose than of style. While Sheeler (115), Weston (112), or the Bruehls (101,120) might apply their practiced eye to a factory or a bridge, they might equally well devote their attention to a piece of fruit or a bit of household decoration for the visual pleasure of themselves or their friends. Sheeler's assistant Maurice Bratter's views of the new George Washington Bridge (106,107) are both social documents and artistic statements. The work of professionals such as Peel (105), Johnston (99,104,113), Harvey (108,110) and Fitz (109,111,116,117) often spanned the varied fields of advertising, portraiture, documentary, and art. Often the photographers were involved in the technical development of the field as well.

This catholicity is very much a reflection of the contemporary world. If George Gershwin appears in an ad for Steinway (116,117), if the

◆

painter Raymond Georg takes a remarkable portrait of the poet Carl Sandburg (119), if Helen Keller and Joe Jefferson, luminaries of two different eras, should appear within the same frame (70), or the Pictorialist Alice Boughton seek out the aging Julia Ward Howe (93), these are simply crosscurrents of the time. In important ways this confluence of image and event, of photography and the opportunities afforded it—depending as it does on the actual for its subject, have formed the most important strand of its tradition in America. The new prominence of the culture and the national history from which these occasions sprang has insured their influence for generations to come. Through the large and important set of works assembled in the George R. Rinhart Collection, as well as the role Mr. Rinhart has played in the founding and expansion of other collections, our view of an era central to our history and that of the modern world will stand more amply revealed.

THOMAS WESTON FELS

◆

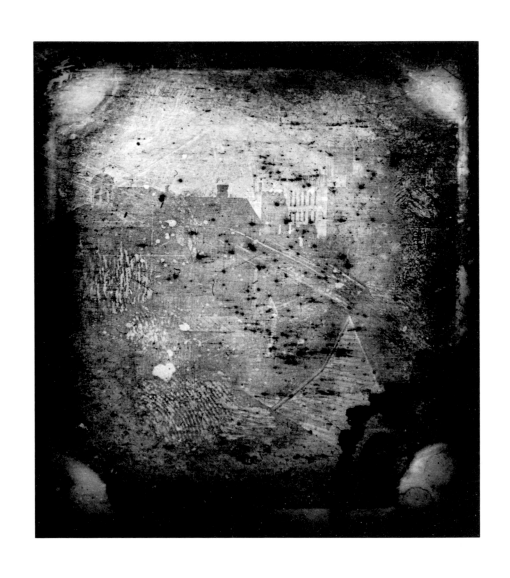

UNKNOWN

City View

Daguerreotype, 1839

◆

22

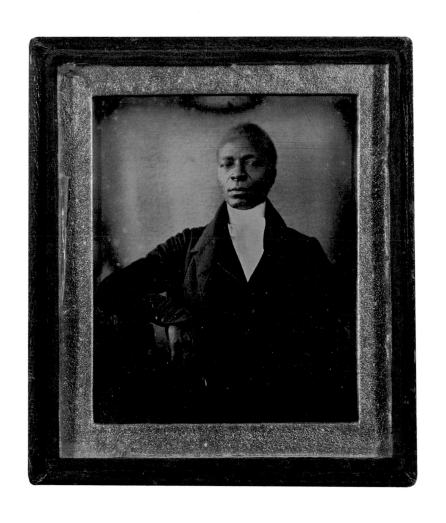

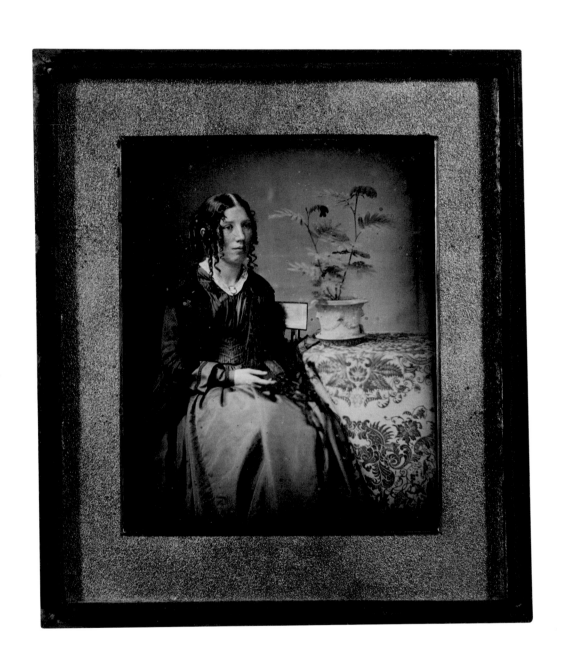

ALBERT SANDS SOUTHWORTH

JOSIAH JOHNSON HAWES

Harriet Beecher Stowe

Daguerreotype, ca. 1843

◆

24

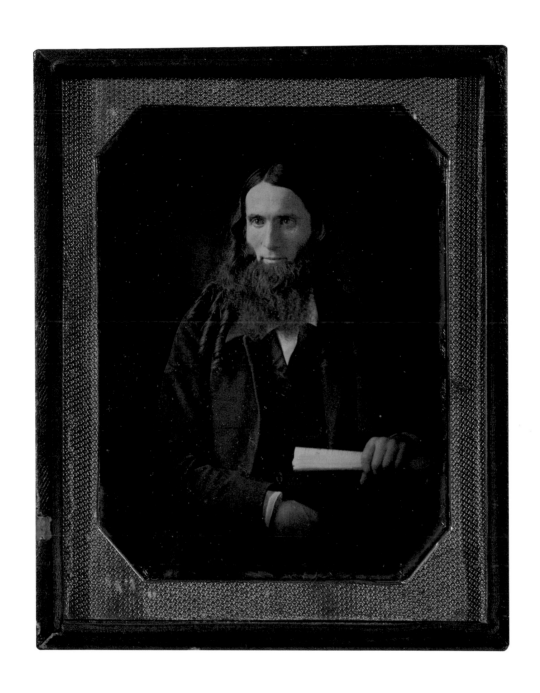

WILLIAM LANGENHEIM

FREDERICK LANGENHEIM

Charles Calistus Burleigh

Daguerreotype, ca. 1843

◆

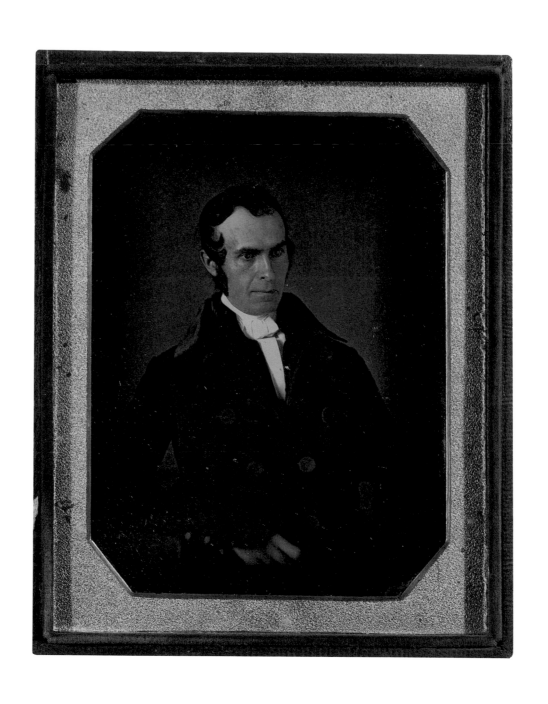

WILLIAM LANGENHEIM

FREDERICK LANGENHEIM

John Greenleaf Whittier

Daguerreotype, ca. 1843

◆

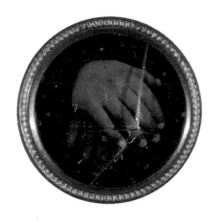

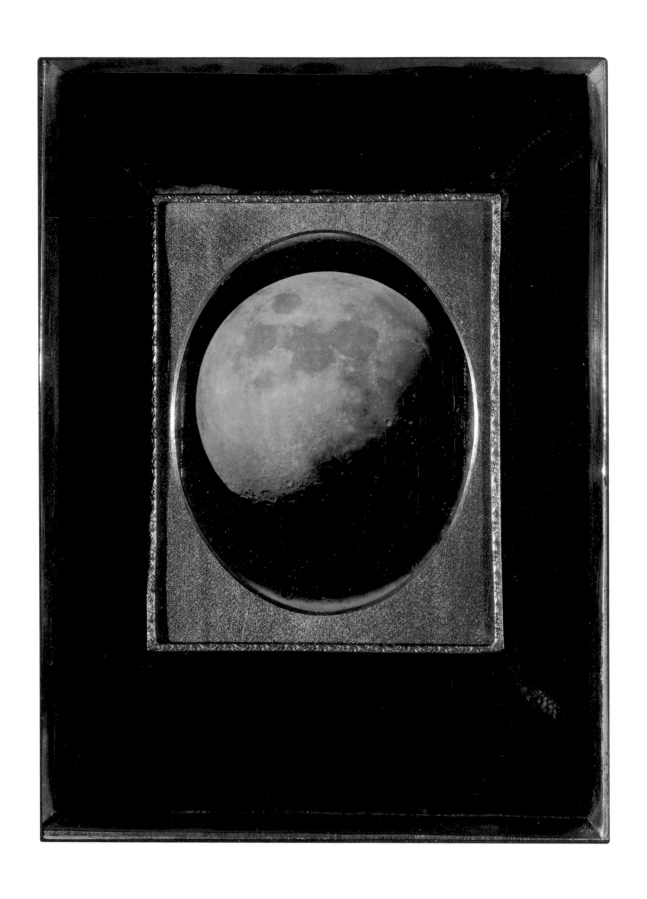

JOHN ADAMS WHIPPLE

The Moon, August 6, 1851

Daguerreotype, 1851

◆

28

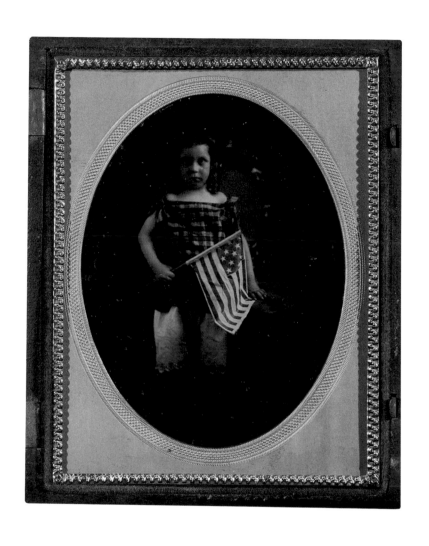

UNKNOWN

Child with American Flag

Daguerreotype, ca. 1856

◆

29

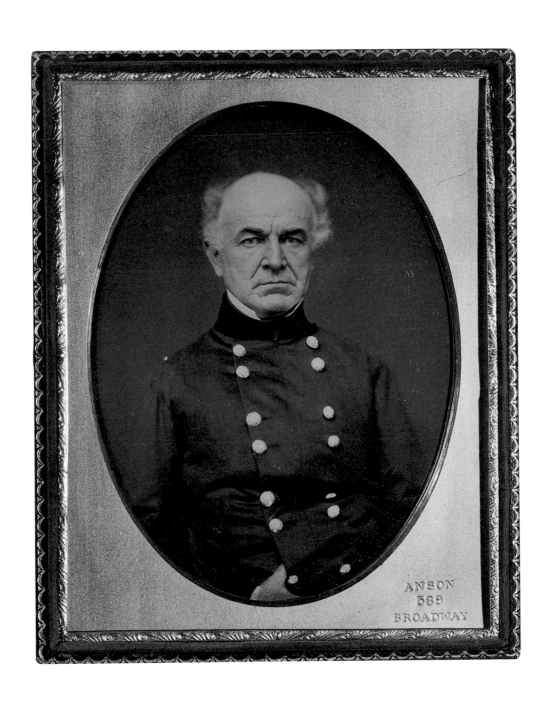

RUFUS ANSON

General Ethan Allen Hitchcock

Daguerreotype, ca. 1857

◆

30

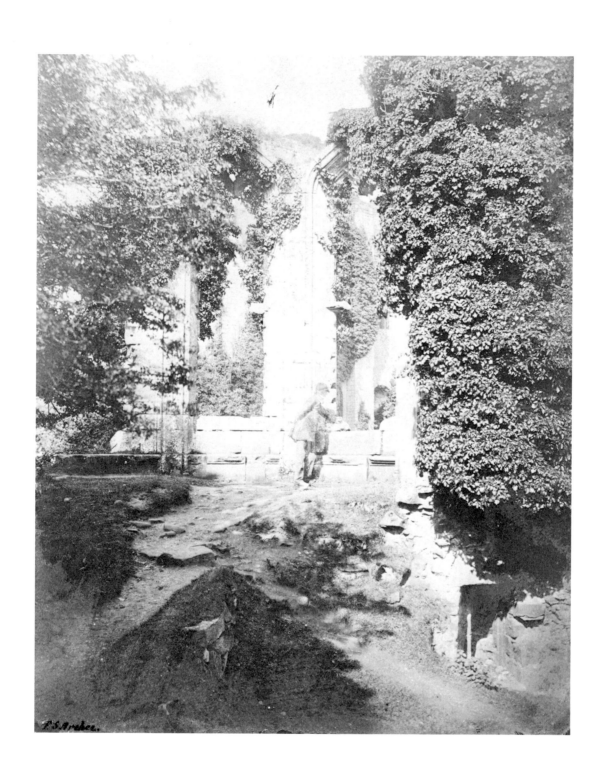

FREDERICK SCOTT ARCHER (British)

Self-portrait, Kenilworth

Salt print from collodion negative, signed, 1851

◆

31

SAMUEL MASURY

On the Loring Estate

Albumenized salt print, ca. 1856

◆

32

SAMUEL MASURY

Landscape, Pride's Crossing

Albumenized salt print, ca. 1856

◆

JOHN B. GREENE

Algeria (Probably near Cherchelle)

Salt print from paper negative, 1856

◆

34

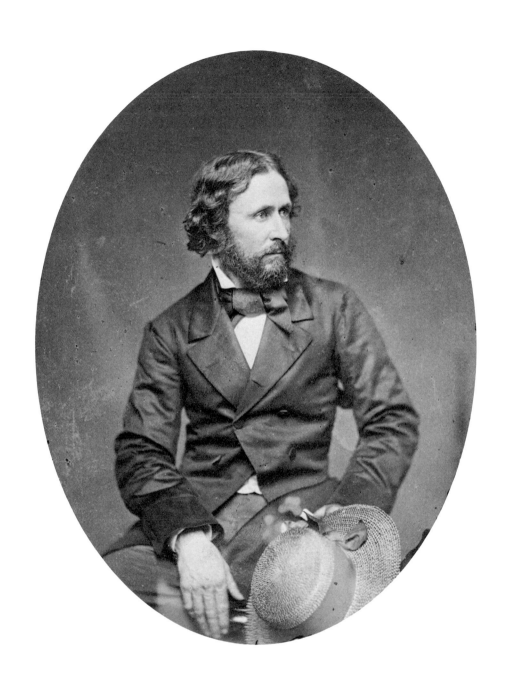

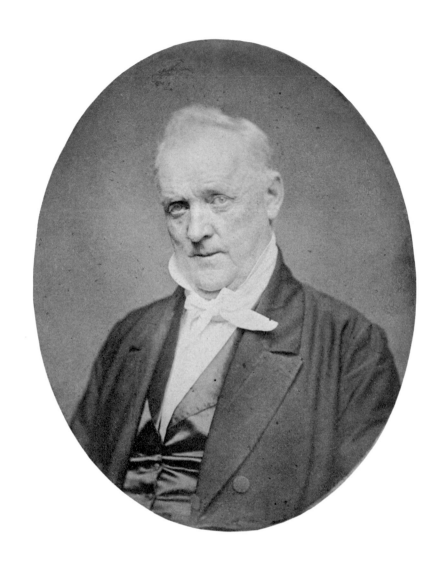

CHARLES RICHARD MEADE

HENRY W. MEADE

James Buchanan, Fifteenth President of the United States

Waxed salt print, 1856-7

◆

36

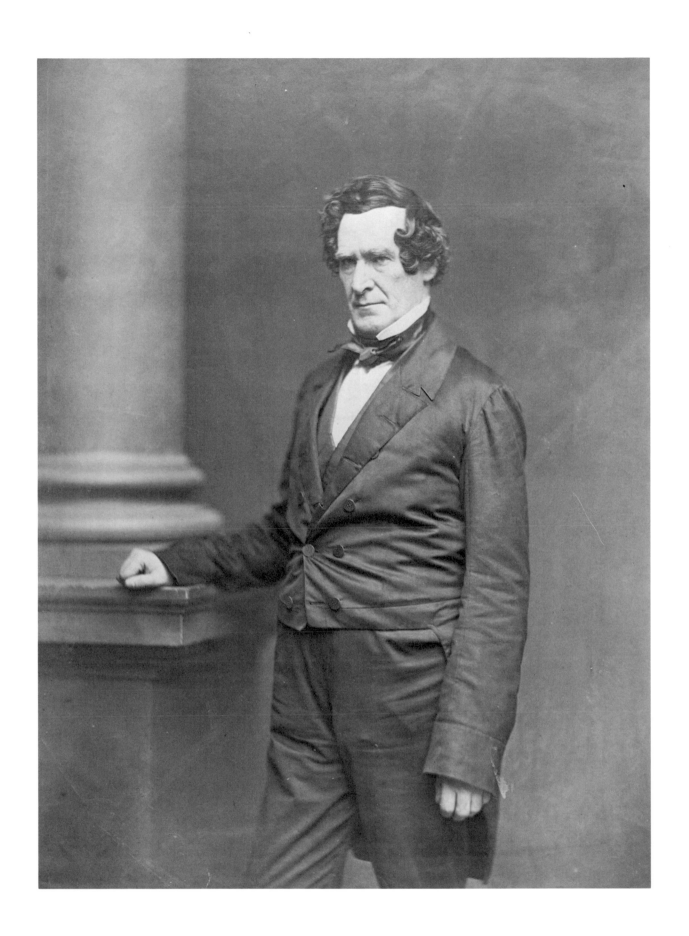

MATHEW BRADY

Jeremiah Black, Statesman

Imperial salt print, ca. 1858

◆

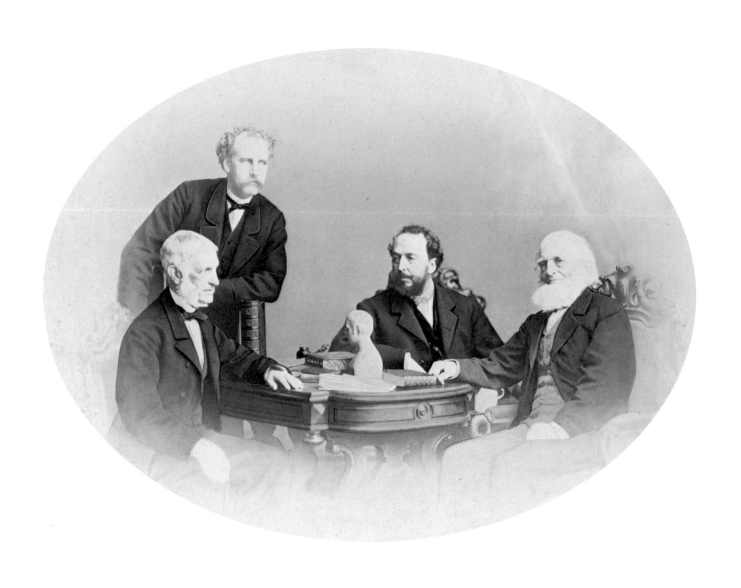

MATHEW BRADY

Literary Group (George Harding Bancroft, George Henry Boker, Bayard Taylor, William Cullen Bryant)

Salt print, ca. 1860

◆

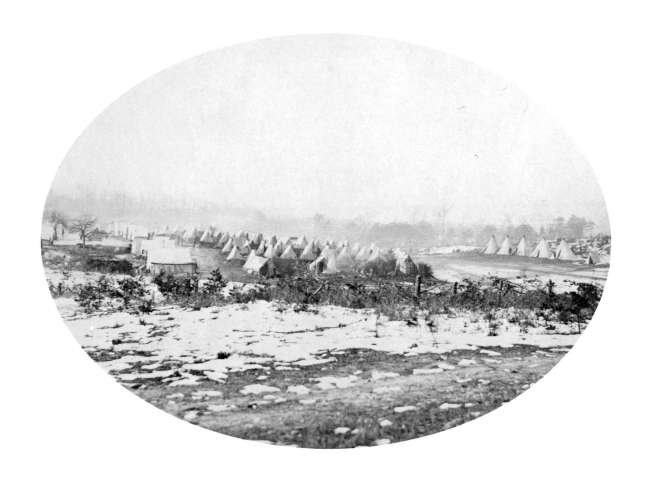

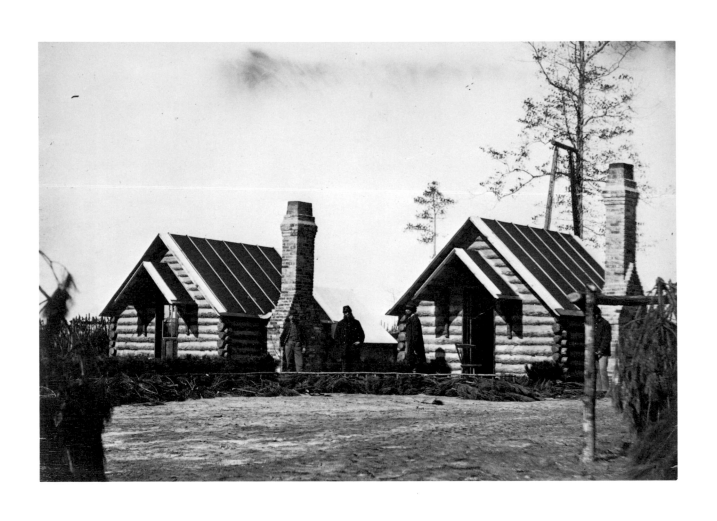

ALEXANDER GARDNER

Camp Houses

Albumen print, ca. 1864

◆

40

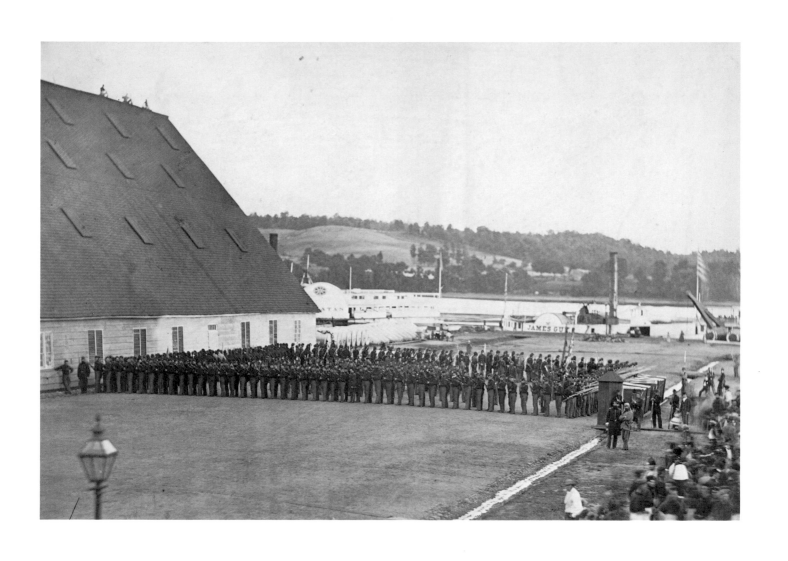

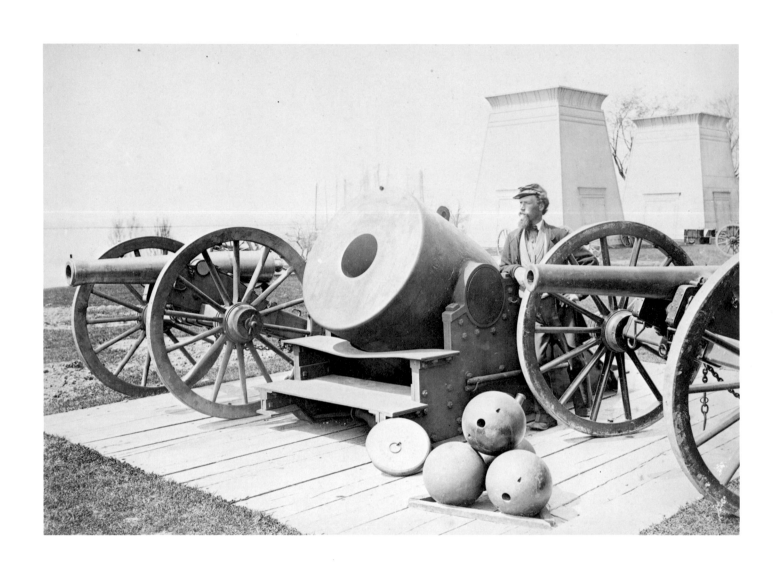

LEWIS EMORY WALKER (attrib.)

Man and Mortar

Albumen print, 1866

◆

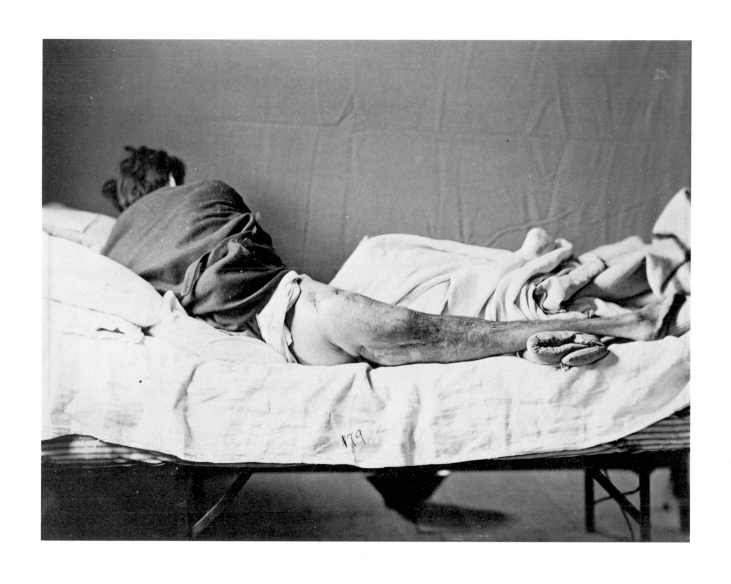

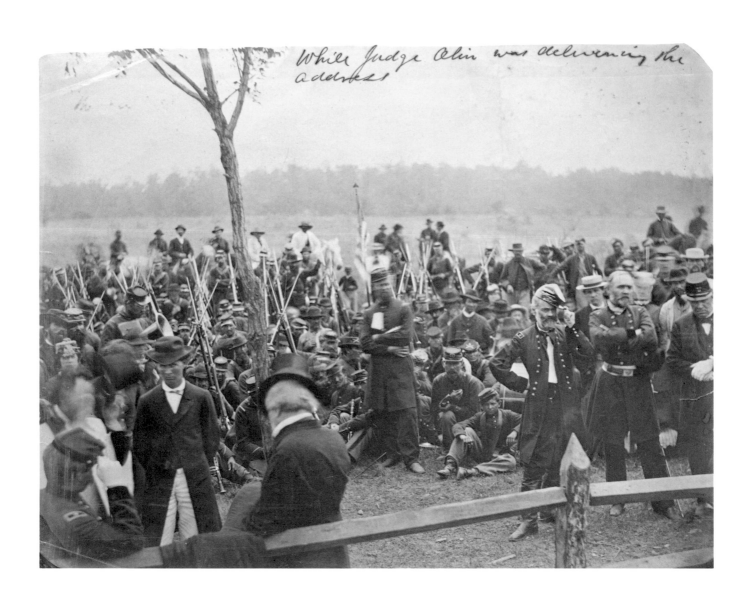

ALEXANDER GARDNER

While Judge Olin Was Delivering the Address

Albumen print, 1865

◆

44

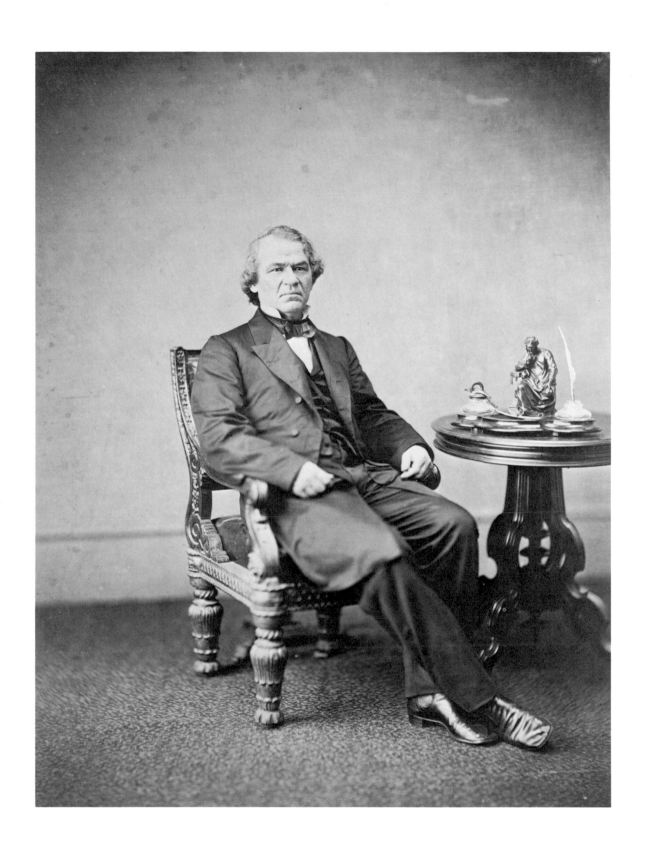

JAMES WALLACE BLACK

Edward Everett Hale and Son

Albumen print, 1869

◆

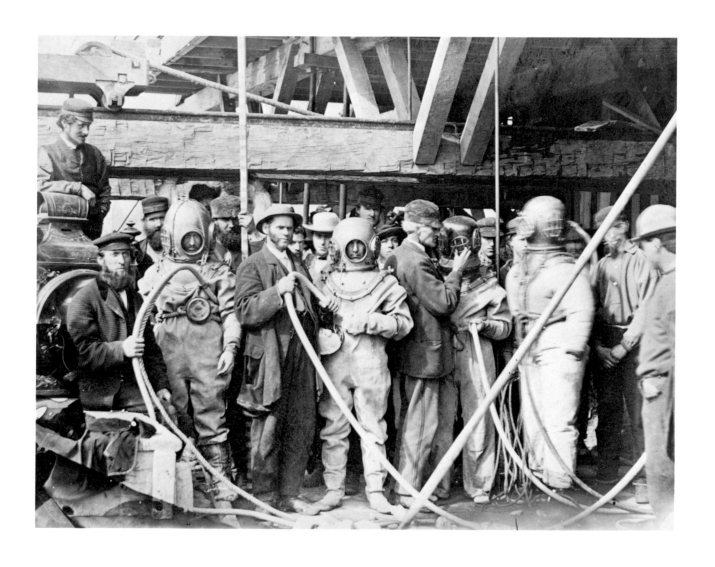

48

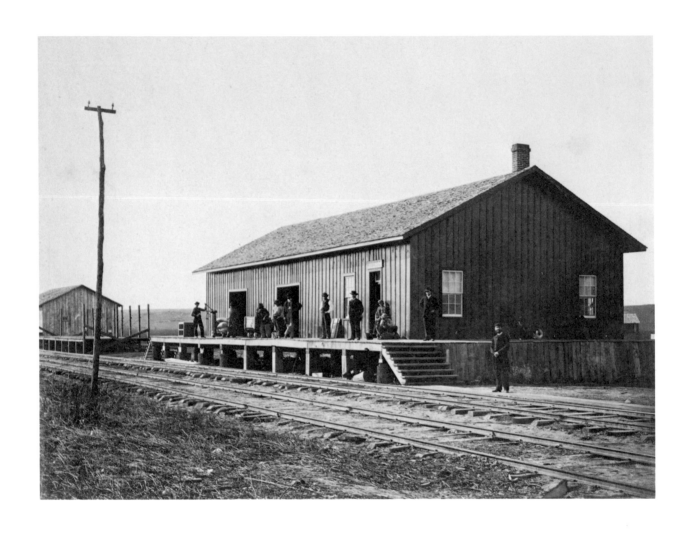

ALEXANDER GARDNER

Railroad Station, Wamego, Kansas

Albumen print, 1866

◆

48

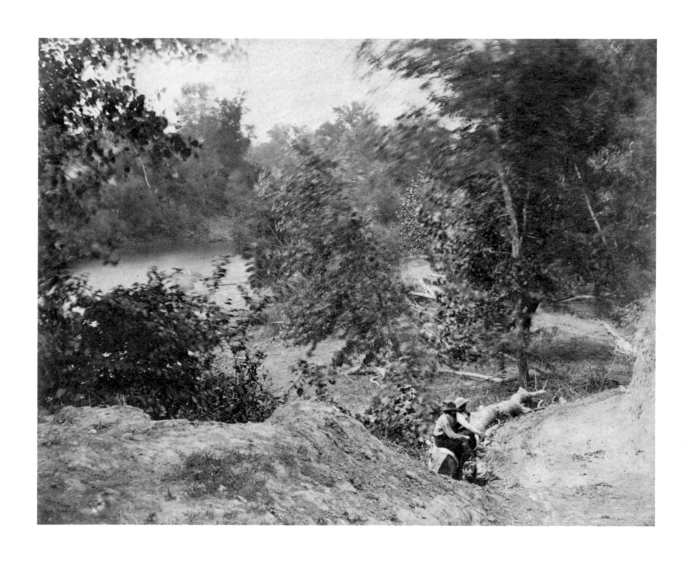

ALEXANDER GARDNER

Self-portrait Along the Route of the Union Pacific Railroad

Albumen print, 1866

◆

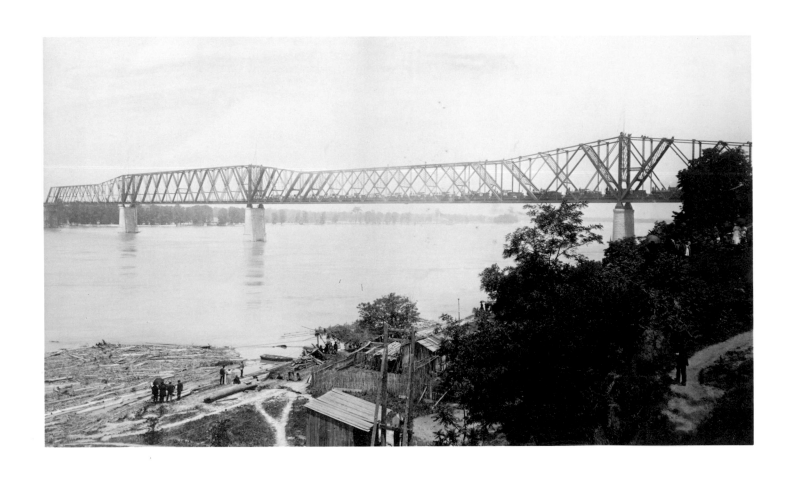

◆

51

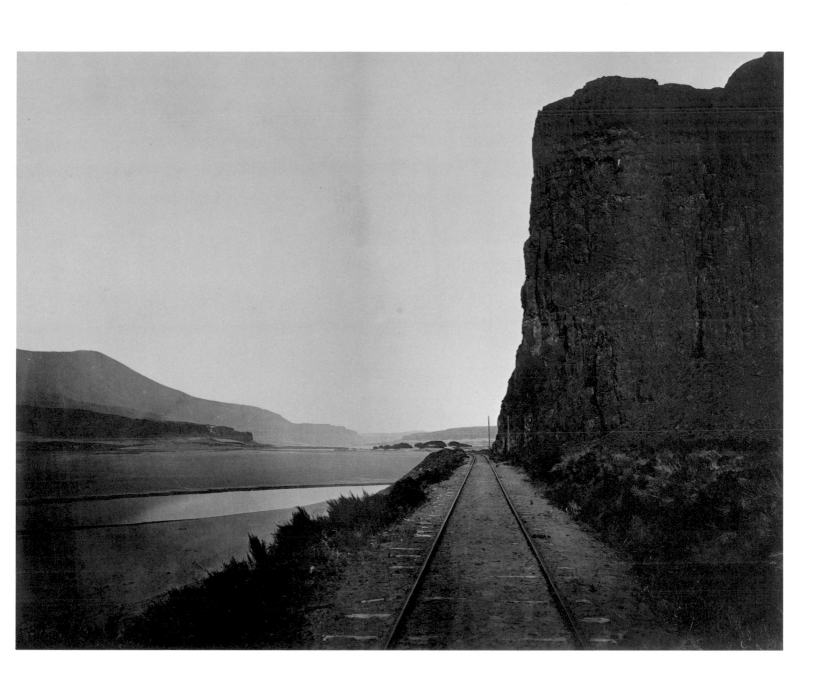

CARLETON WATKINS

Cape Horn, Near Celilo

Albumen print, 1867

◆

51

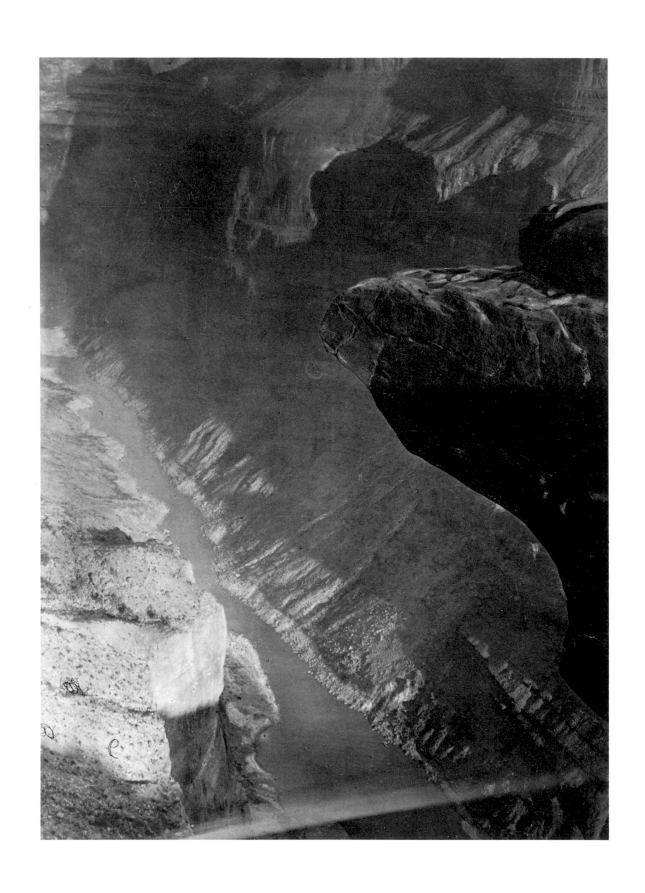

WILLIAM BELL

Looking South into the Grand Canyon of the Colorado River at Sheavwitz Crossing

Albumen print, 1872

◆

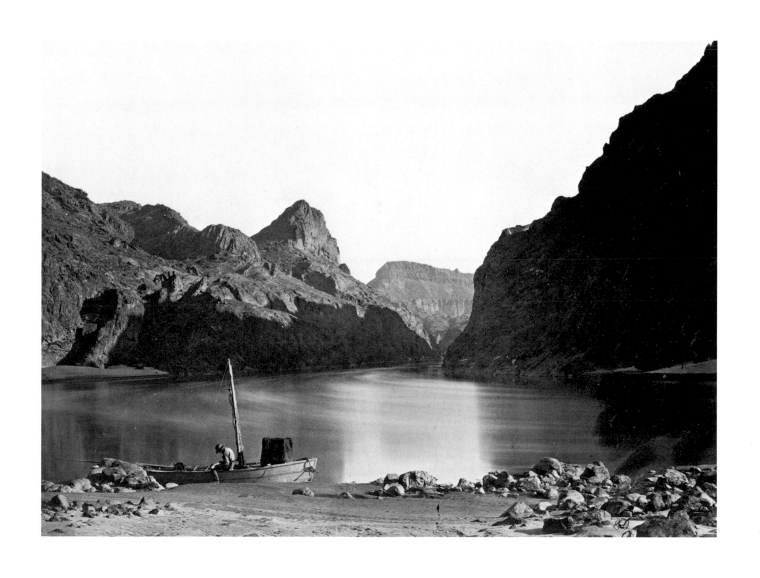

TIMOTHY O'SULLIVAN

Black Canyon, Arizona, Wheeler Survey

Albumen print, 1871

◆

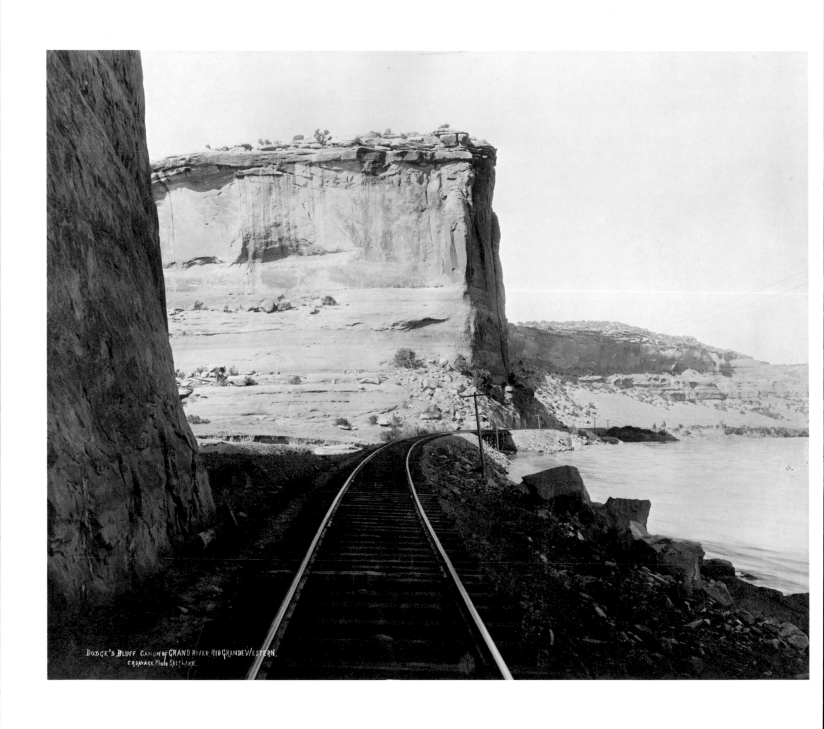

Charles Savage

Dodge's Bluff, Canyon of Grand River, Rio Grande Western Railroad

Albumen print, ca. 1881

◆

54

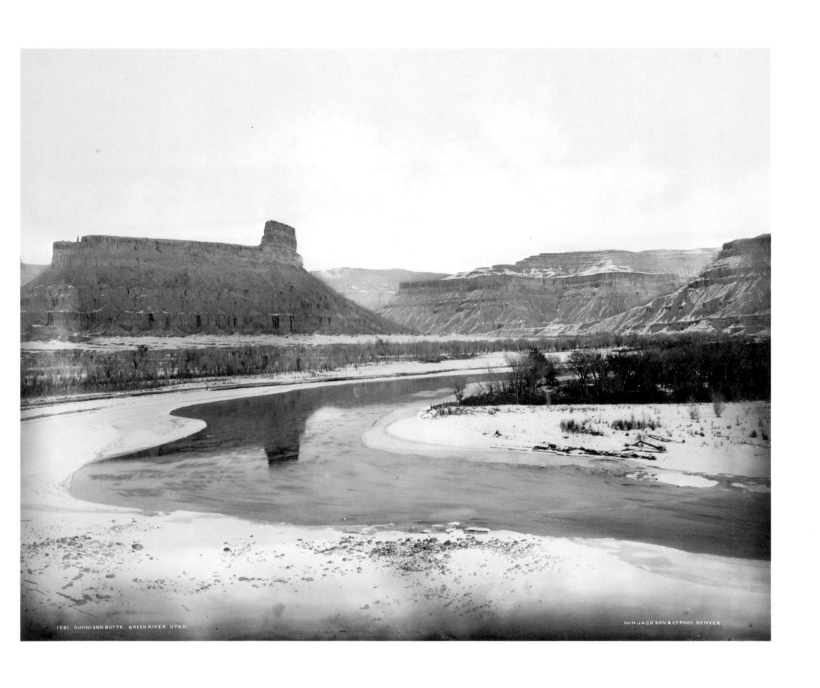

WILLIAM HENRY JACKSON

Gunnison Butte, The Green River, Utah

Albumen print, 1876

◆

55

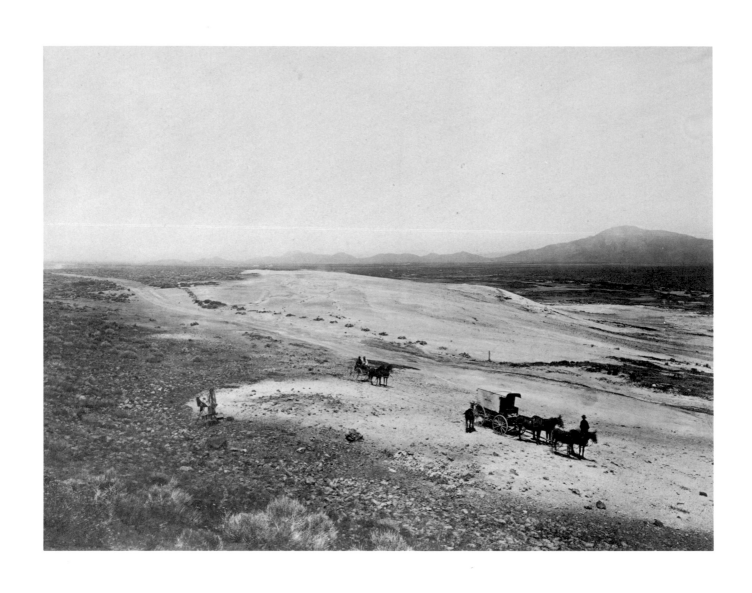

TIMOTHY O'SULLIVAN

Wagon in Desert, King Survey, Nevada

Albumen print, 1868

◆

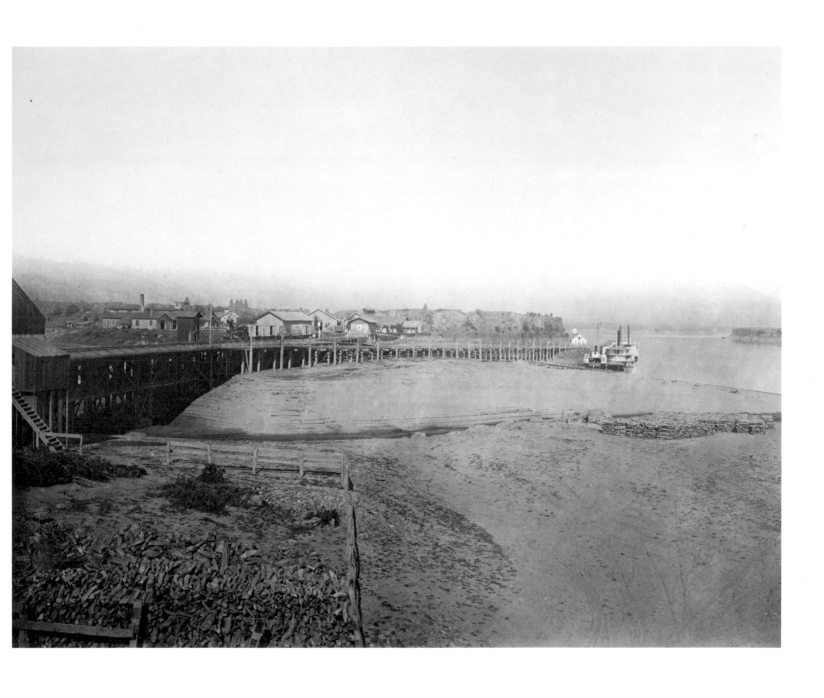

CARLETON WATKINS

Oregon Steam Navigation Company Works, Dalles City, Columbia River

Albumen print, 1867

◆

57

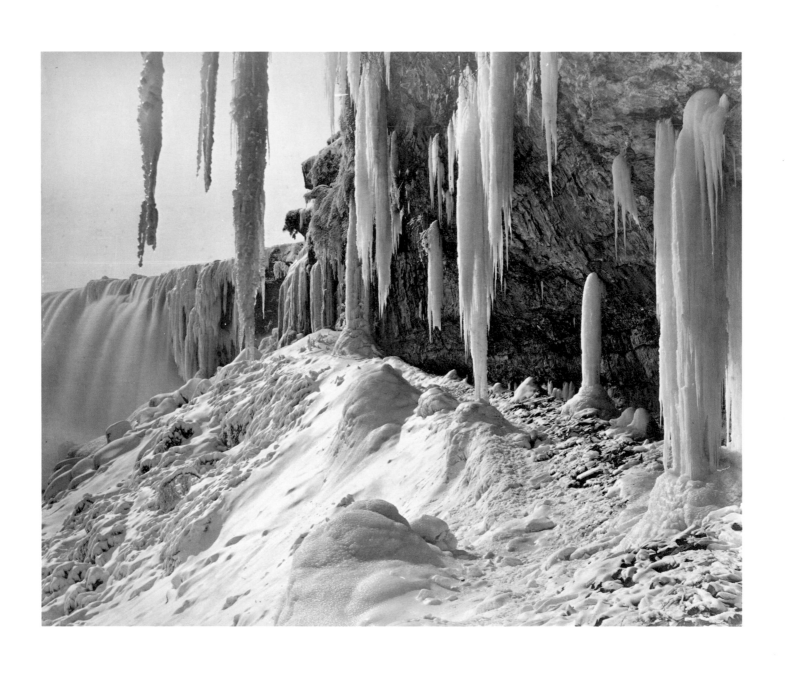

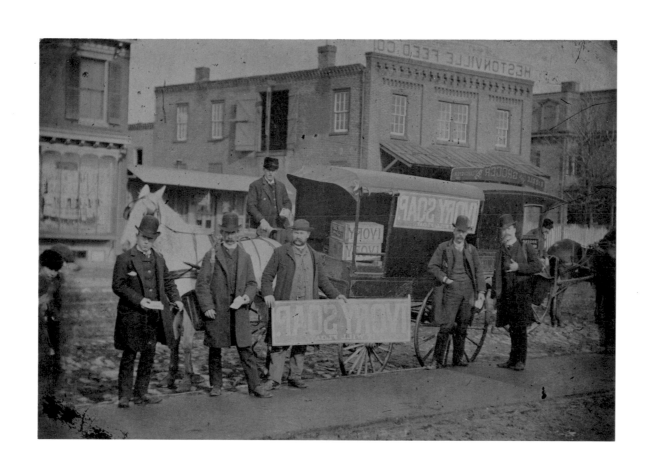

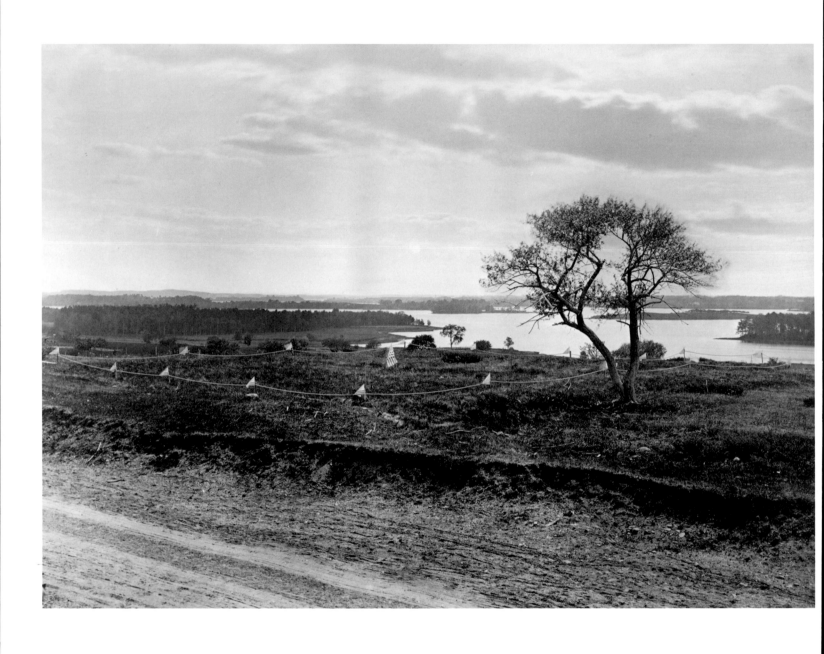

DAVID W. BUTTERFIELD

Dover Neck, New Hampshire

Albumen print, ca. 1875

◆

60

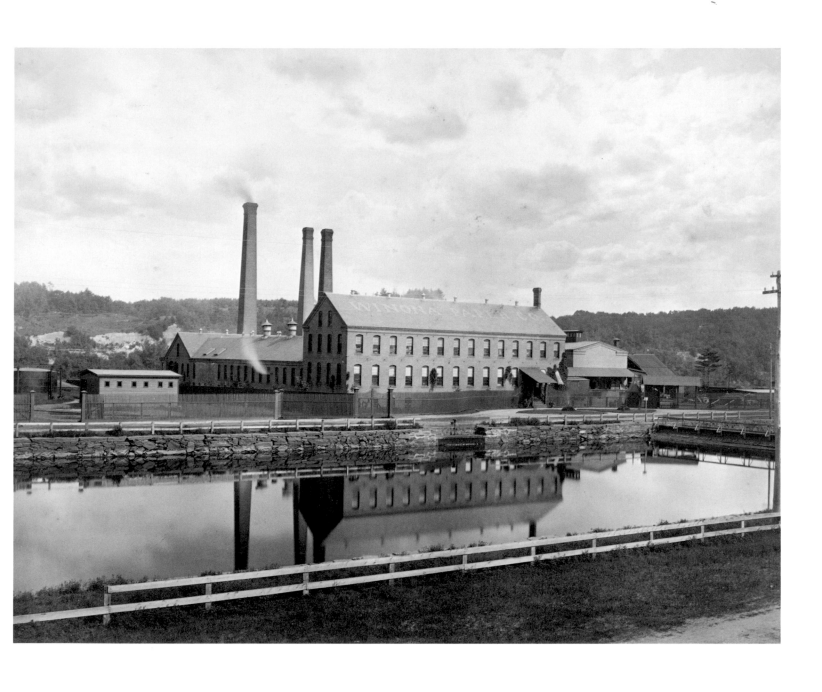

DAVID W. BUTTERFIELD

Mills of the Winona Paper Company, Chicopee, Massachusetts

Albumen print, ca. 1875

◆

61

62

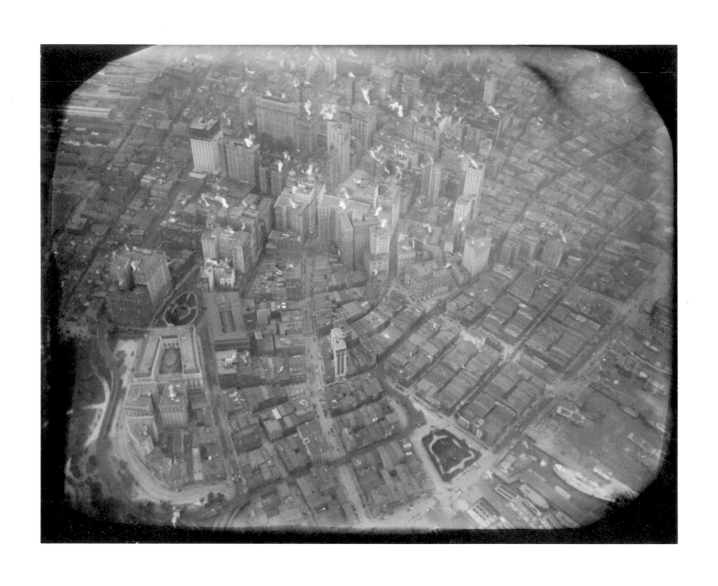

JAMES H. (JIMMY) HARE

First Aerial Photo of New York, from Balloon

Silver print, 1906

◆

62

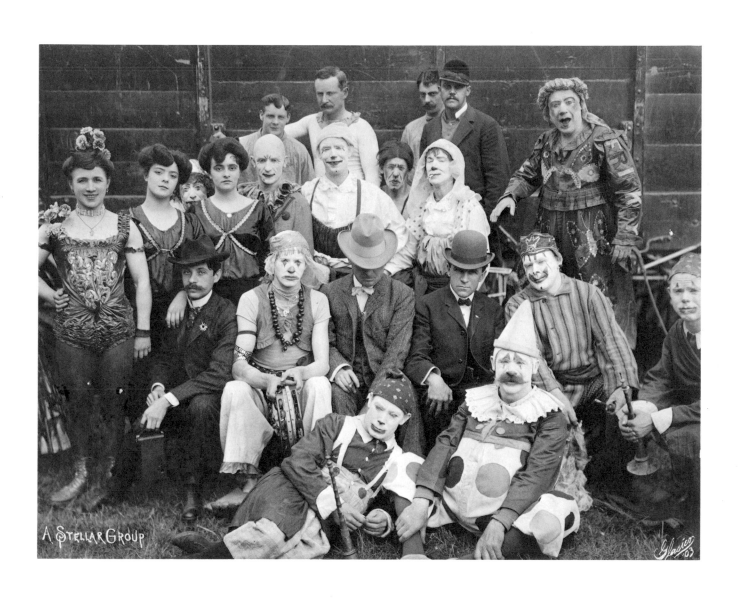

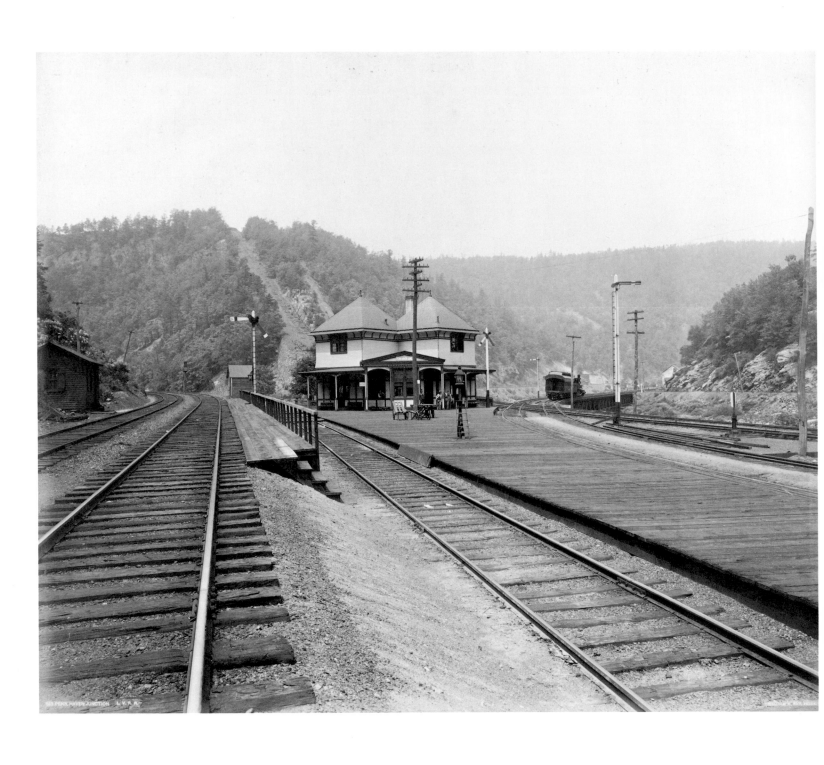

WILLIAM H. RAU

Penn Haven Junction

Albumen print, ca. 1888

◆

64

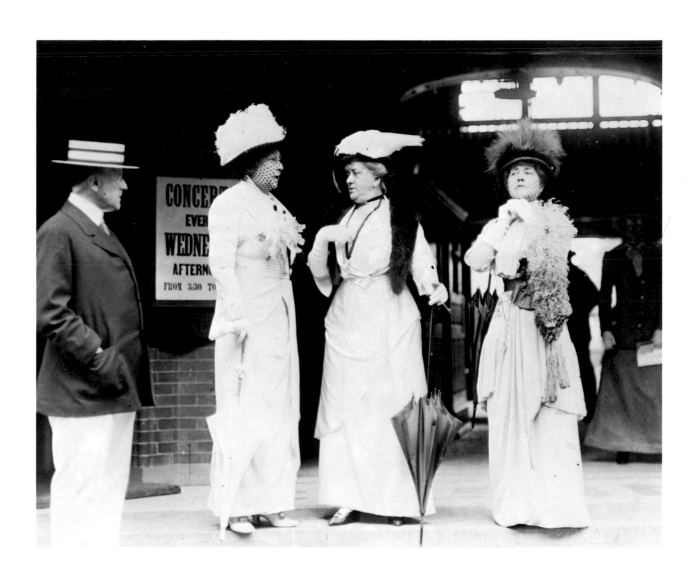

UNDERWOOD AND UNDERWOOD

Society Ladies at Annual Horse Show, Newport, R.I.

Silver print, 1913

◆

65

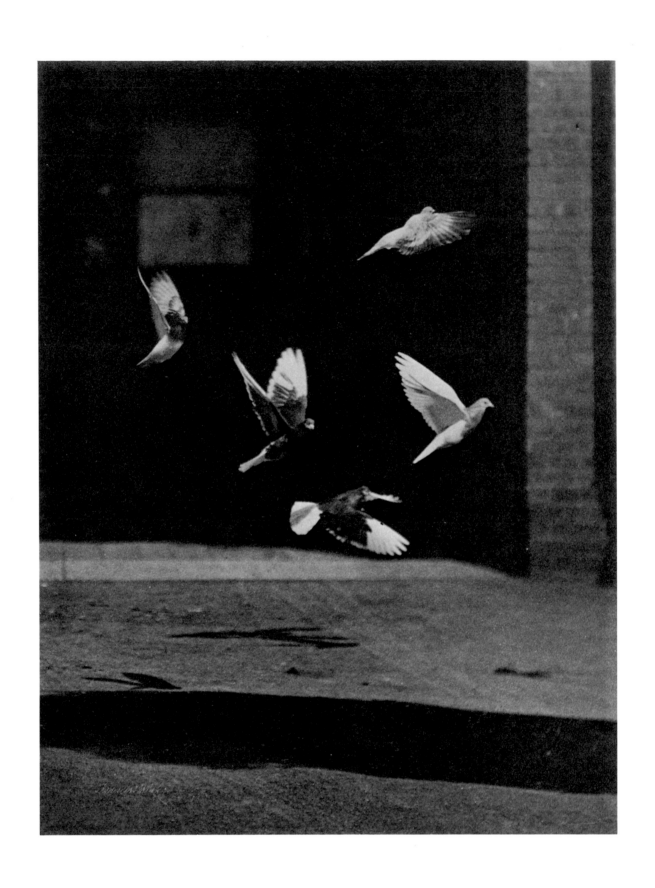

FRANCIS BLAKE

Pigeons in Flight

Platinum print, ca. 1888

◆

66

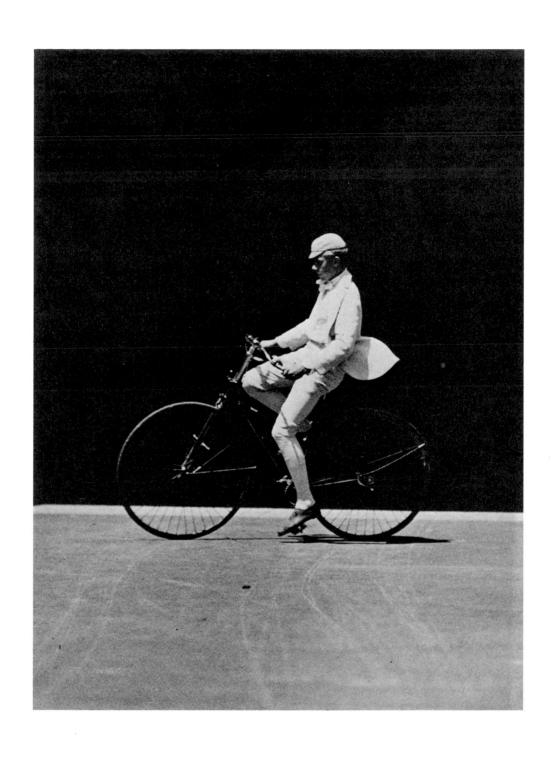

FRANCIS BLAKE

Man on Bicycle

Platinum print, ca. 1888

◆

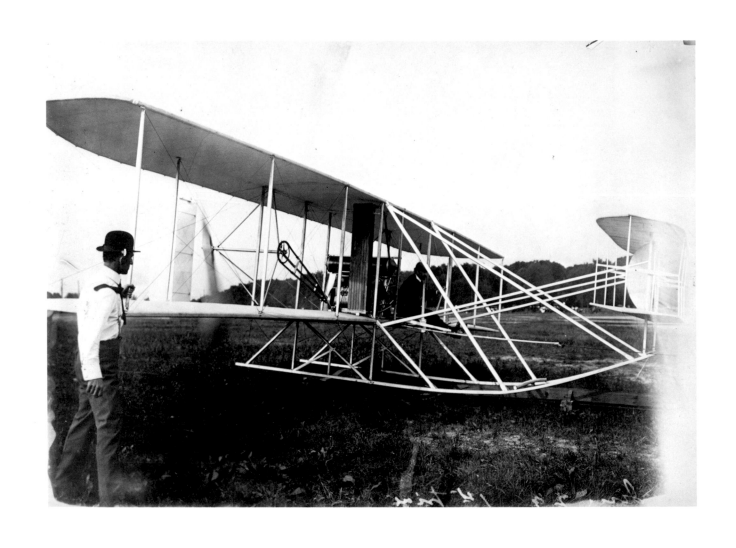

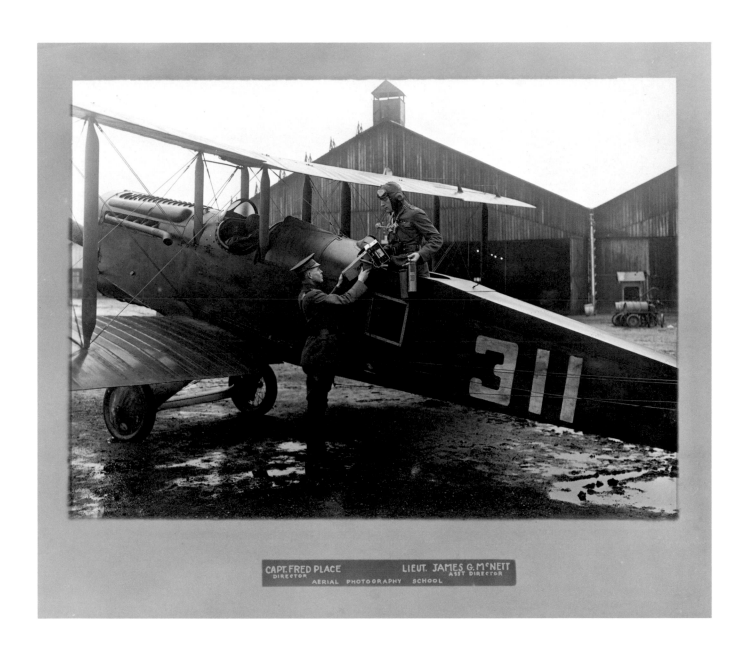

CAPT. FRED PLACE
DIRECTOR
LIEUT. JAMES G. McNETT
ASST DIRECTOR
AERIAL PHOTOGRAPHY SCHOOL

UNKNOWN PHOTOGRAPHER, ALLIED EXPEDITIONARY FORCES

Aerial Photographer and Plane

Silver print, 1918

◆

C.M. Gilbert

Chat-about-the-Hand

(Joe Jefferson and Helen Keller)

Silver print, ca. 1900

◆

GEORGE COX

Portrait of Edward MacDowell

Albumen, ca. 1888

◆

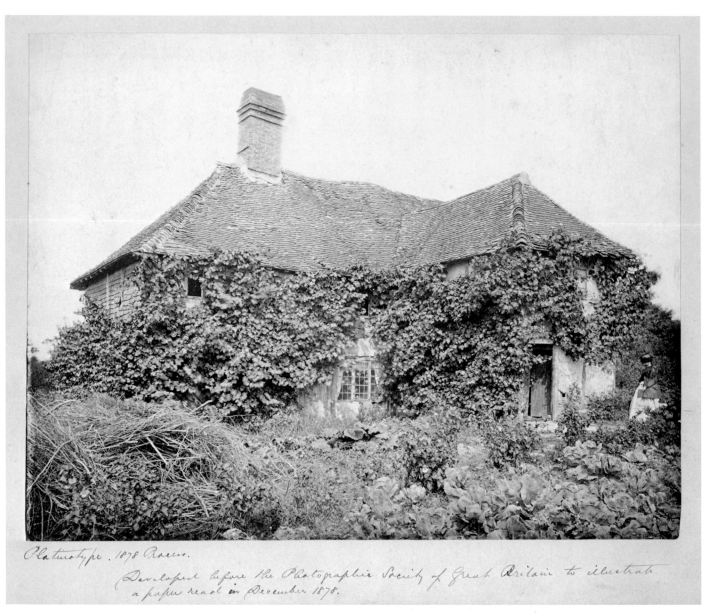

Platinotype. 1878 Process.

Developed before the Photographic Society of Great Britain to illustrate a paper read in December 1878.

WILLIAM WILLIS (British)

Cottage Scene

Platinotype (1878 process), 1878

◆

72

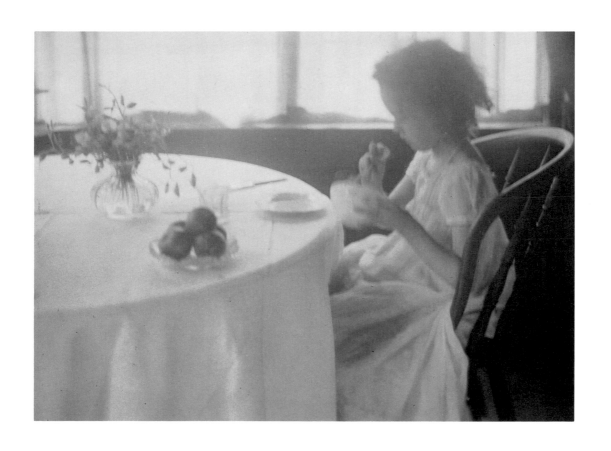

EMA SPENCER

Girl at Table with Peaches

Cyanotype, ca. 1900

◆

WILLIAM B. POST

The Critic (Alfred Stieglitz and Frank Hermann)

Platinum print, ca. 1893

◆

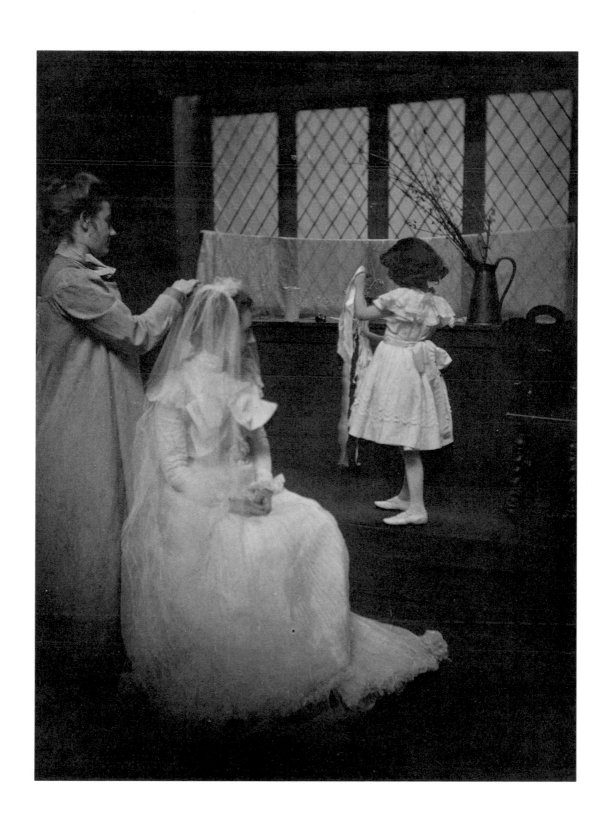

GERTRUDE KASEBIER

The Wedding

Platinum Print, 1899

◆

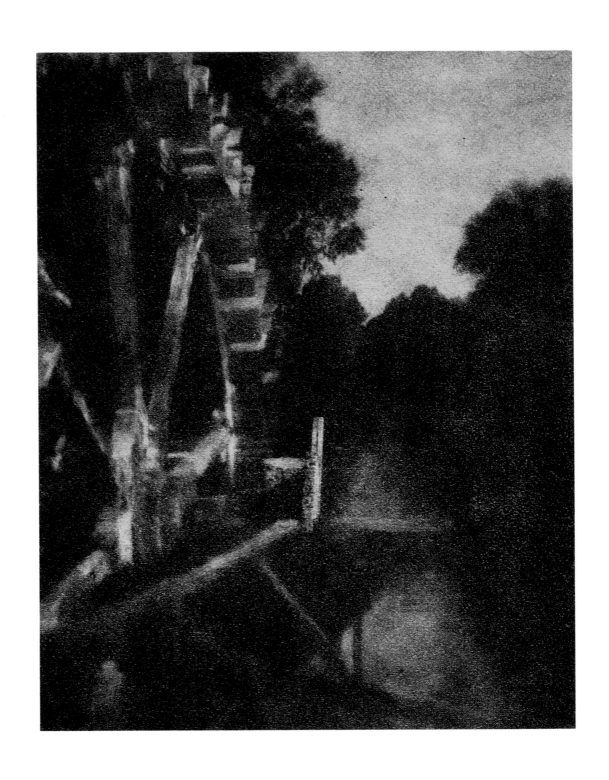

ALVIN LANGDON COBURN OR

WILLIAM ORISON UNDERWOOD

The Mill at Ipswich

Gum and platinum, ca. 1902

◆

76

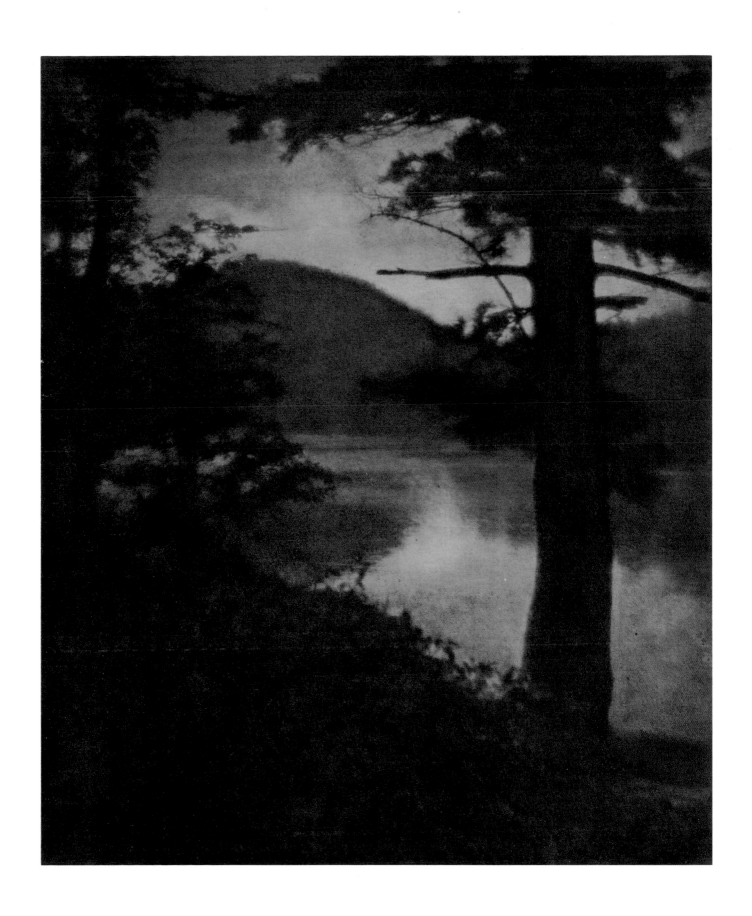

Dr. Rupert S. Lovejoy

Finale

Multiple gum print, 1916

◆

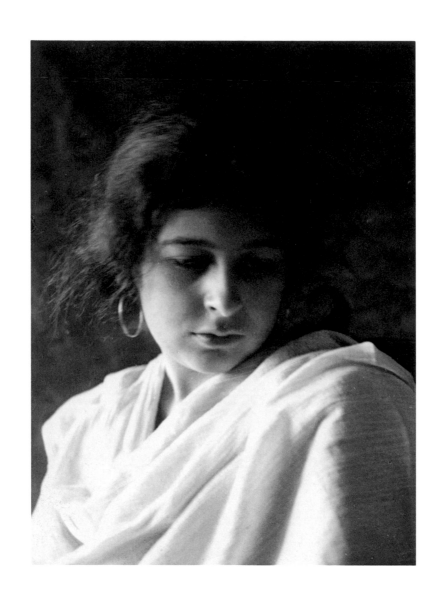

F. HOLLAND DAY

Pepita

Platinum print, ca. 1896

◆

◆

79

BERTRAM H. WENTWORTH

Cholla

Platinum print, 1896

◆

79

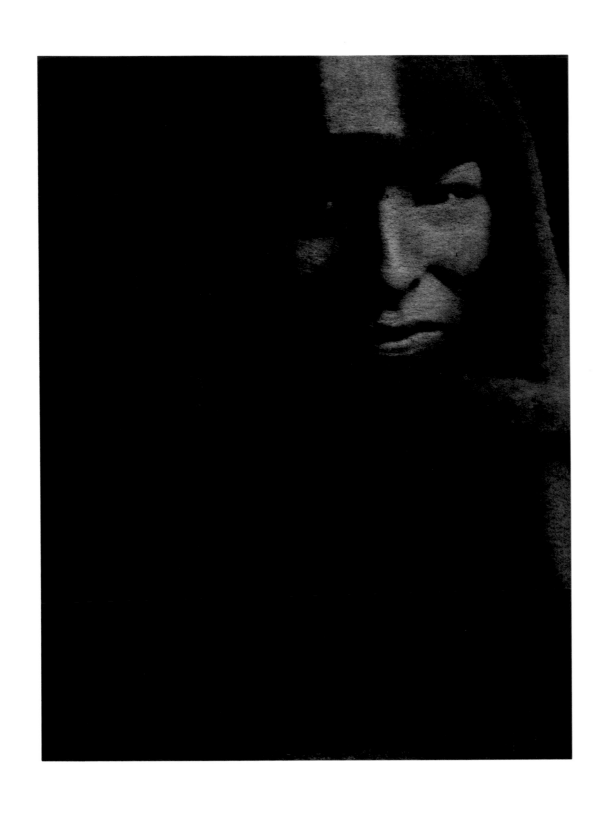

GERTRUDE KASEBIER

The Red Man

Gum over platinum, 1901-2

◆

80

GERTRUDE KASEBIER

Happy Days

Platinum, 1902

◆

82

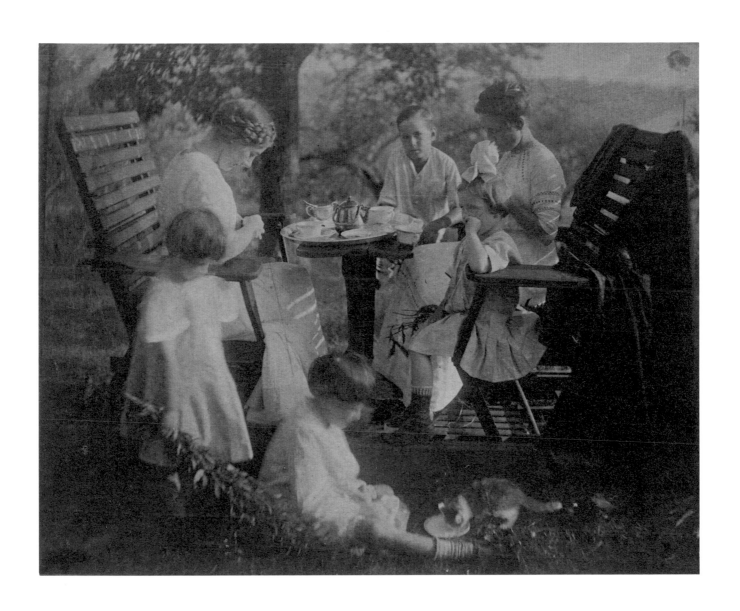

GERTRUDE KASEBIER

Summertime

Platinum on tissue, sepia toned, ca. 1910

◆

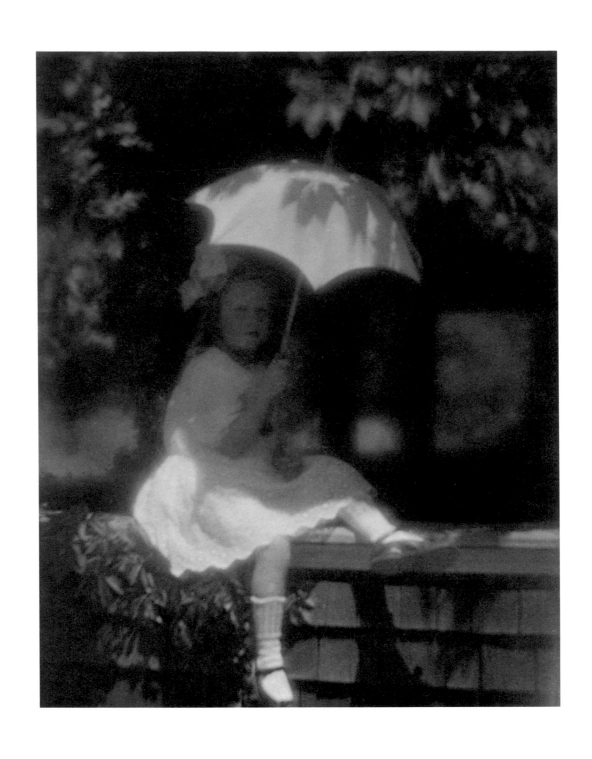

DWIGHT A. DAVIS

Little Girl with Parasol

Platinum print, ca. 1904

◆

84

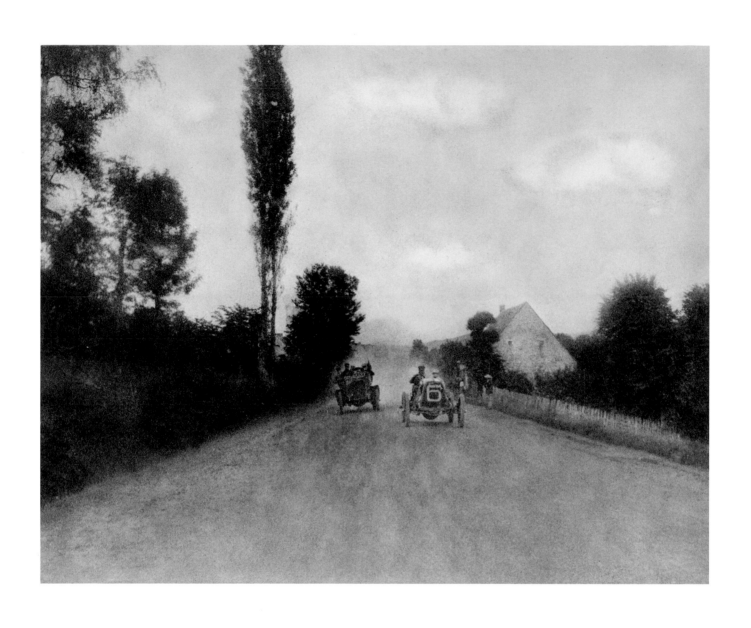

ALBERT ERNEST SCHAAF

The Race

Oil pigment print, 1905

◆

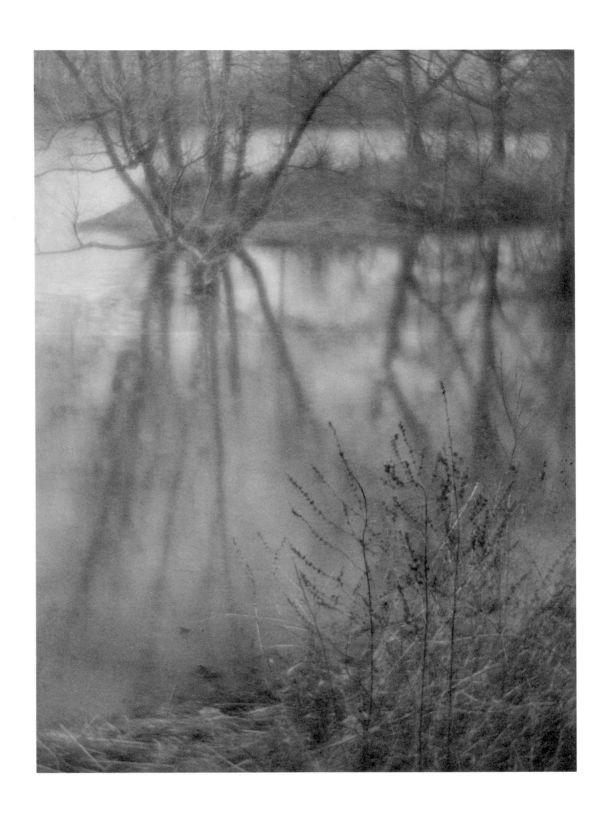

JOHN CHISLETT

Trees

Platinum print, ca. 1904

◆

DWIGHT A. DAVIS

A Pool in the Woods

Gum over platinum, ca. 1906

◆

87

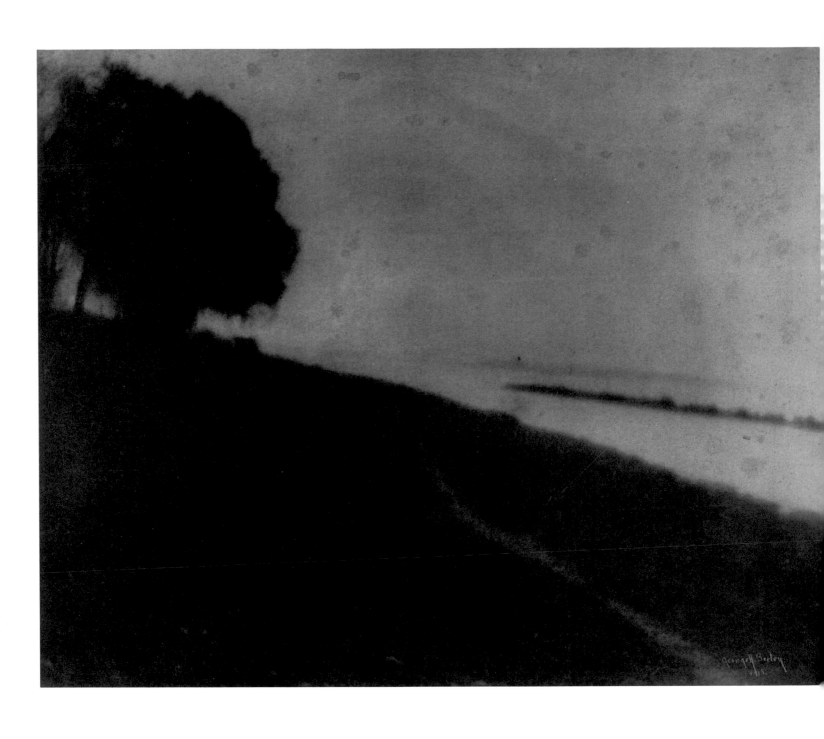

George H. Seeley

Landscape

Gum over platinum, 1912

◆

88

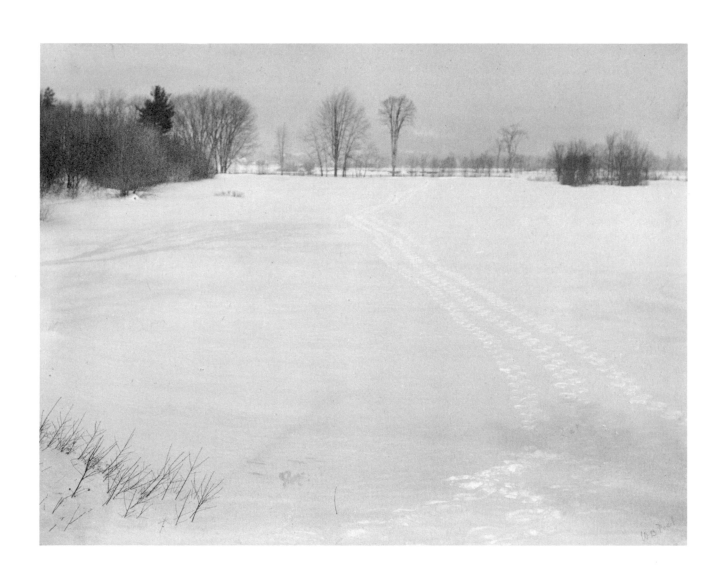

WILLIAM B. POST

Intervale, Winter

Platinum print, 1898

◆

89

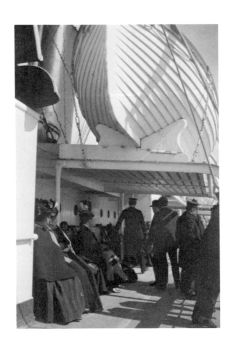

WILLIAM JAMES MULLINS

The Lifeboat

Silver print, ca. 1899

◆

WILLIAM JAMES MULLINS

Stieglitz Working in Gallery

Silver print, 1912

◆

91

THOMAS O'CONOR SLOANE, JR.

Mme. Sato

Gum platinum print, ca. 1908

◆

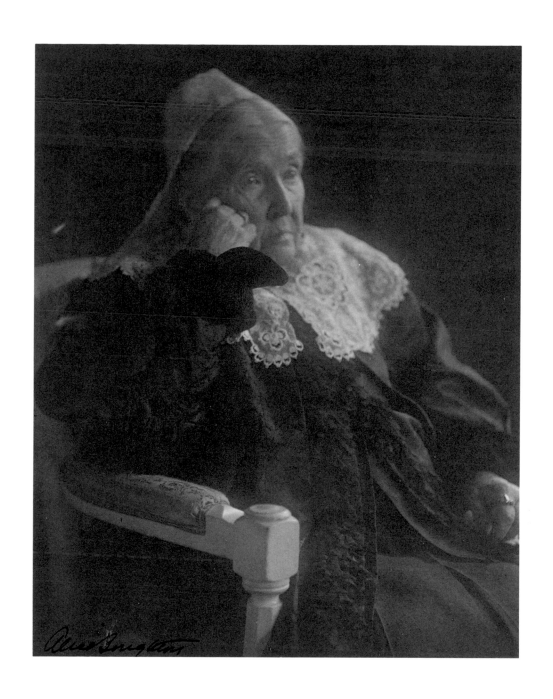

ALICE BOUGHTON

Portrait of Julia Ward Howe

Platinum print, 1908

◆

93

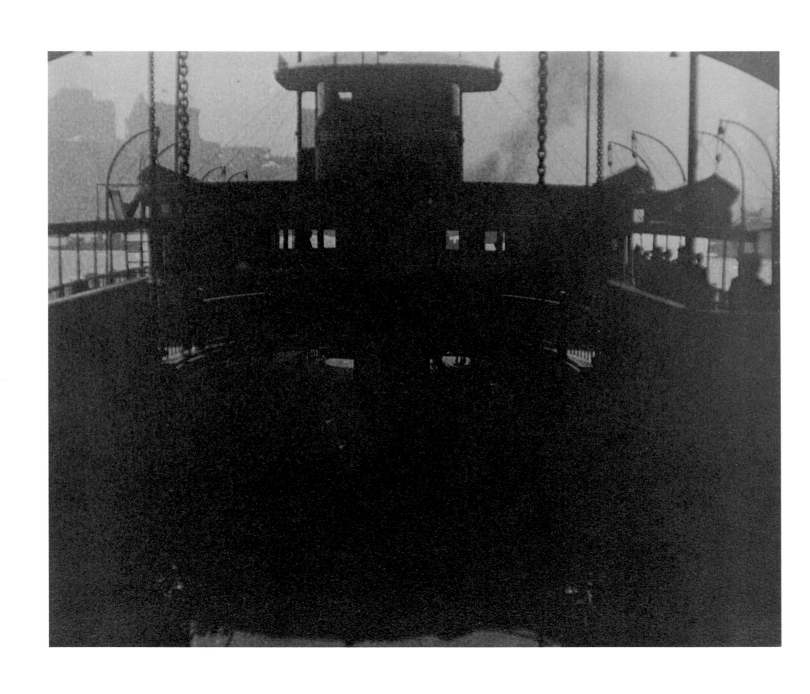

WALTER R. LATIMER, SR.

Ferryboat

Silver print, 1915

◆

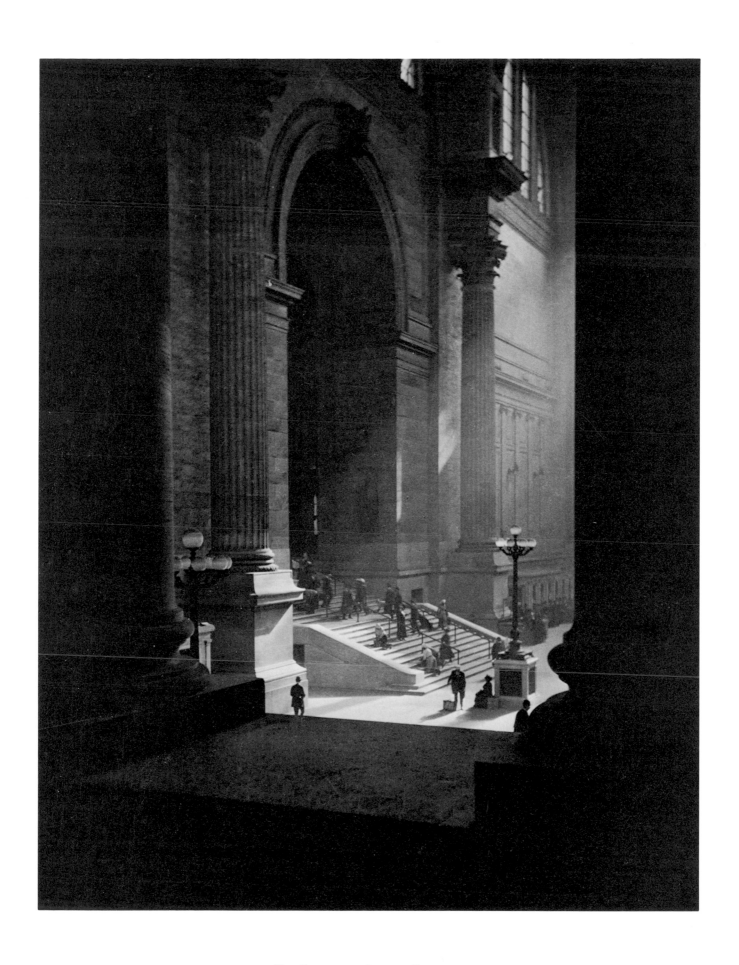

DR. DRAHOMIR JOSEPH RUZICKA

Penn Station, New York

Silver print, 1919

◆

95

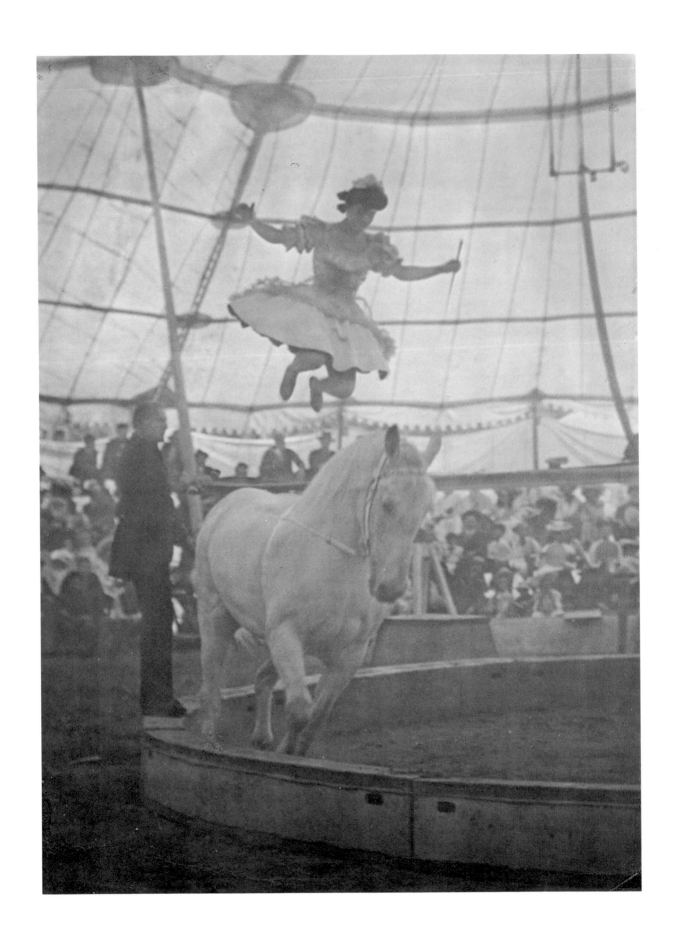

HARRY C. RUBINCAM

The Circus

Platinum print, 1902

◆

96

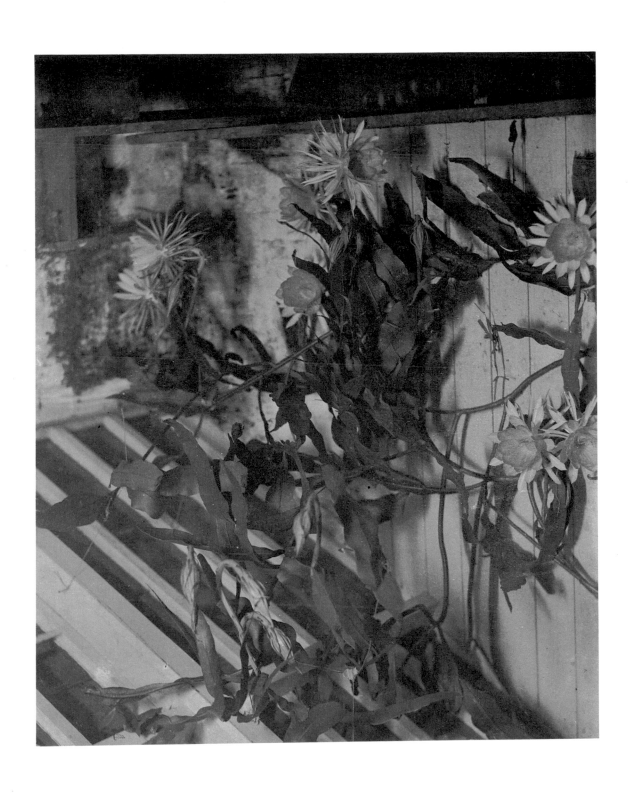

LOUIS COMFORT TIFFANY

Floral Decoration

Cyanotype, ca. 1890

◆

97

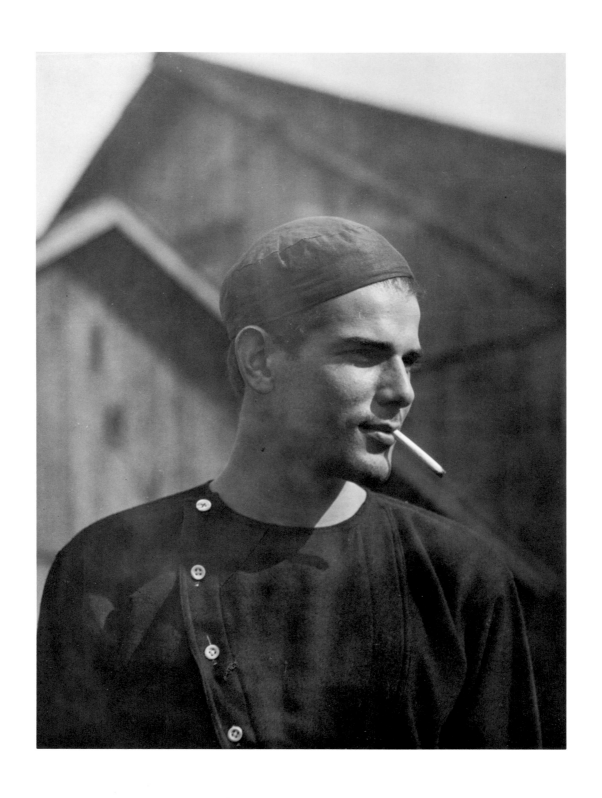

STELLA SIMON

Louis

Silver print, 1925

◆

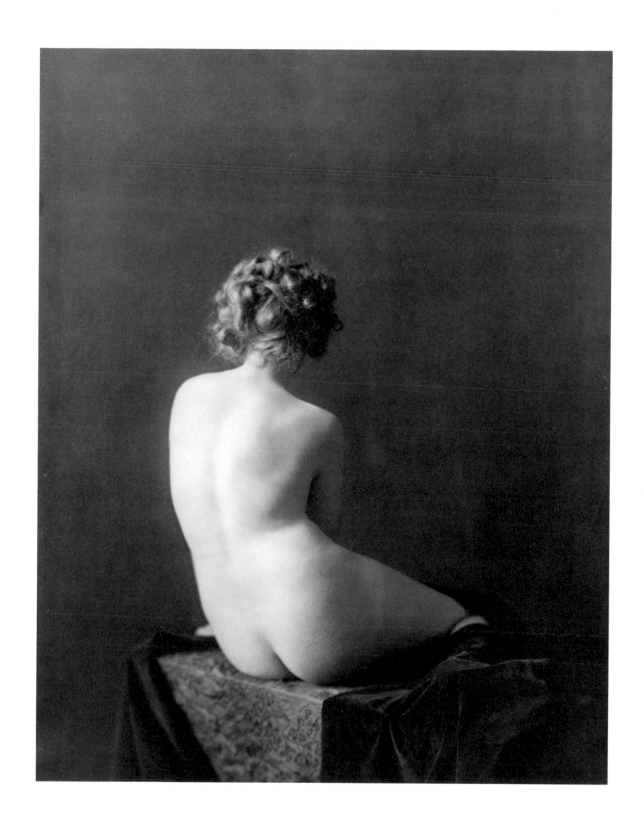

ALFRED CHENEY JOHNSTON

Nude

Silver print, ca. 1922

◆

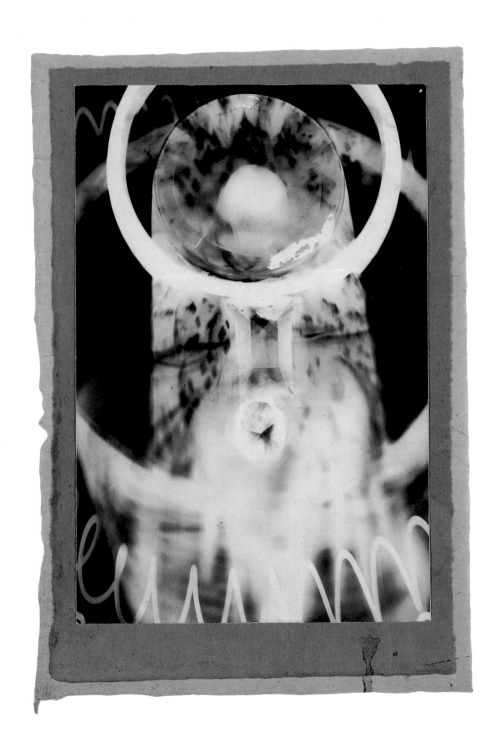

Man Ray

Inspiration

Photogram, ca. 1922

◆

100

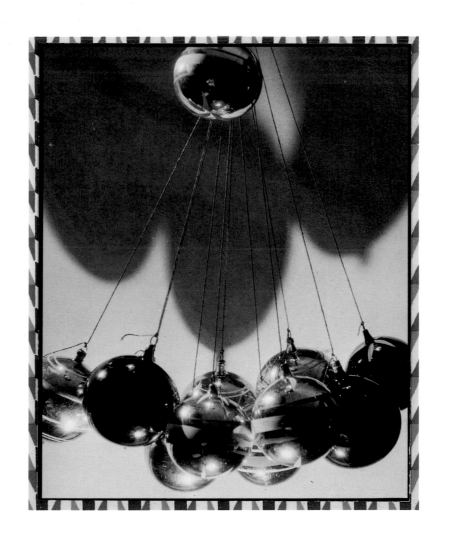

ANTON BRUEHL

Still Life, Glass Spheres

Platinum print, 1925

◆

101

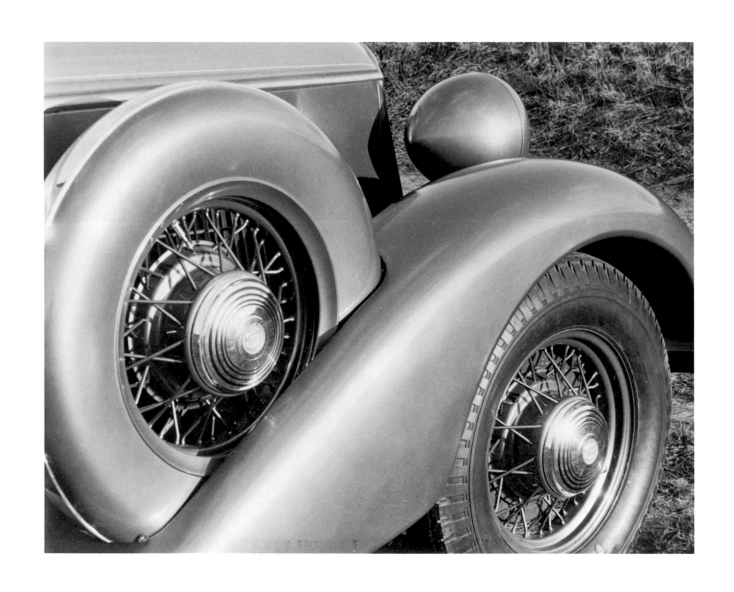

MAURICE BRATTER

Torso of Car

Silver print, ca. 1932

◆

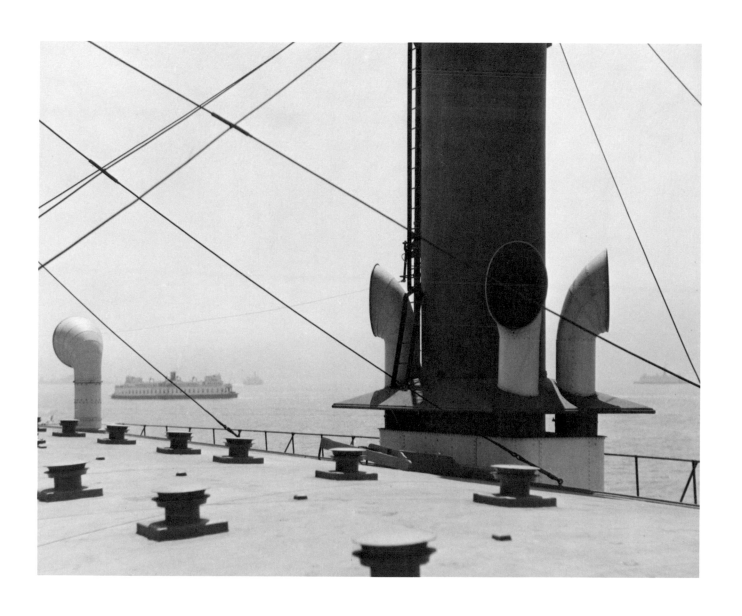

WILLIAM E. DASSONVILLE

Ship's Deck

Silver print, ca. 1926

◆

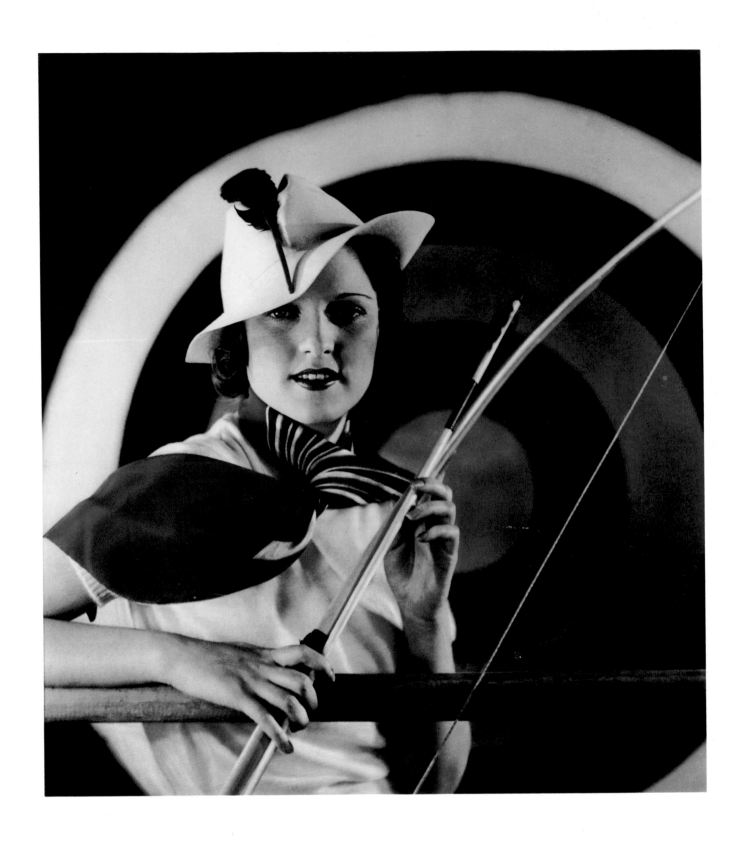

ALFRED CHENEY JOHNSTON

The Target

Color carbro print, ca. 1931

◆

104

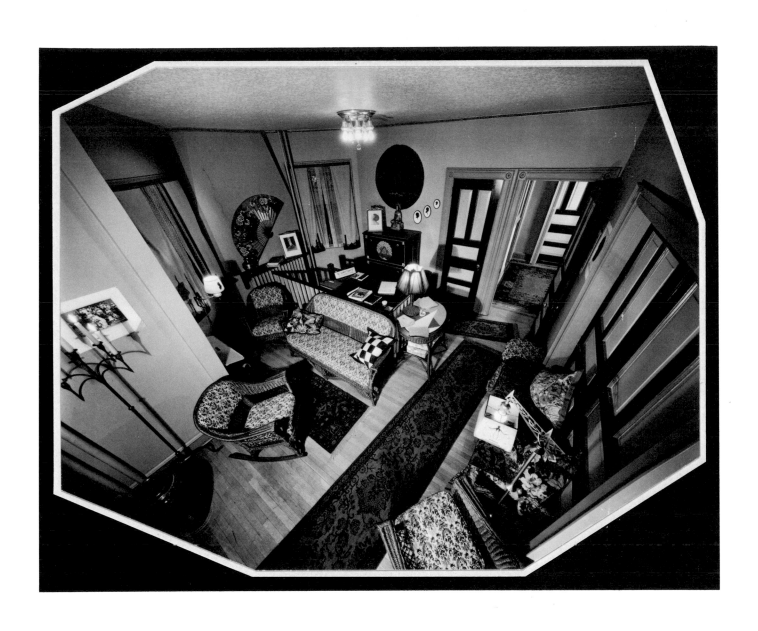

FRED PEEL

The Reception Room

Silver bromide print, 1931

◆

105

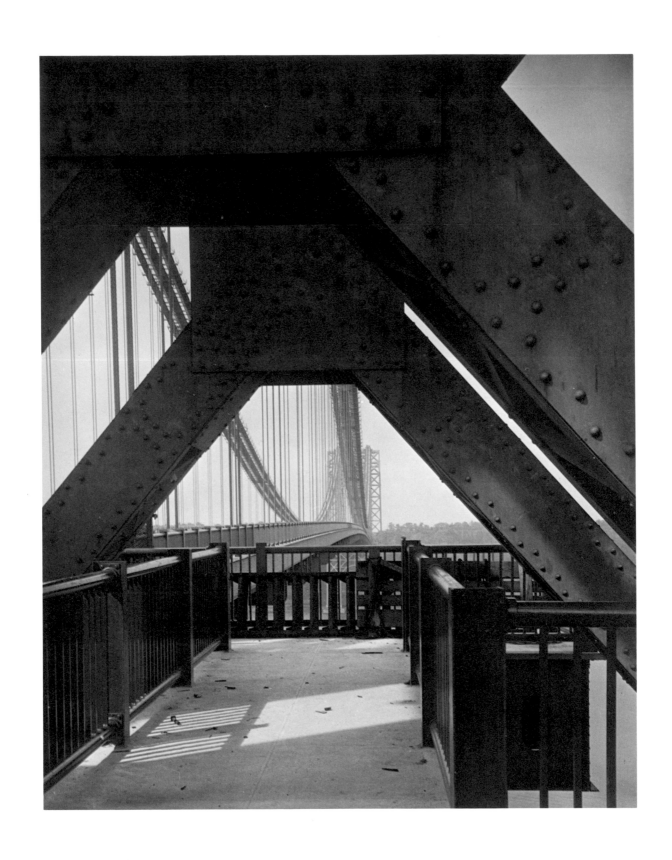

MAURICE BRATTER

George Washington Bridge

Palladium print, ca. 1931

◆

106

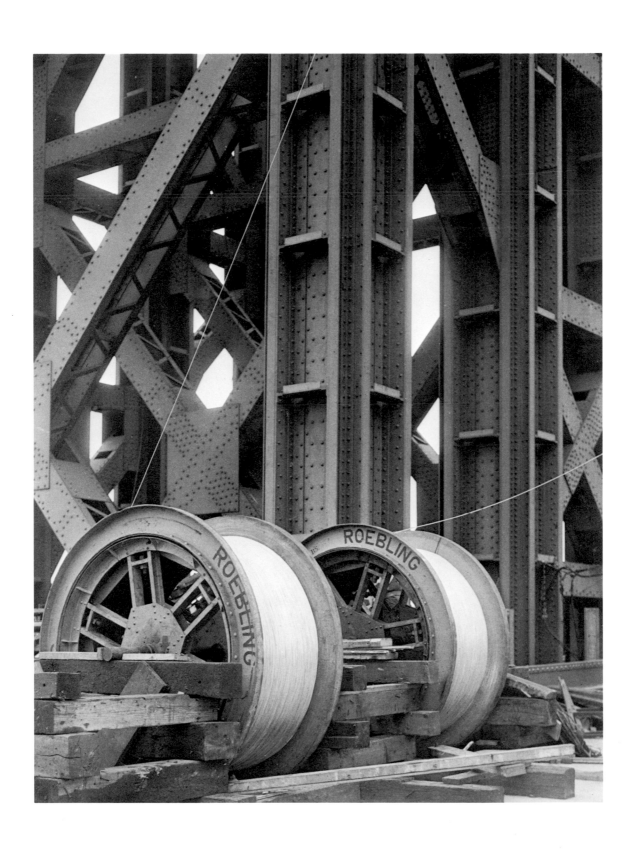

MAURICE BRATTER

Roebling Steel

Palladium print, ca. 1930

◆

107

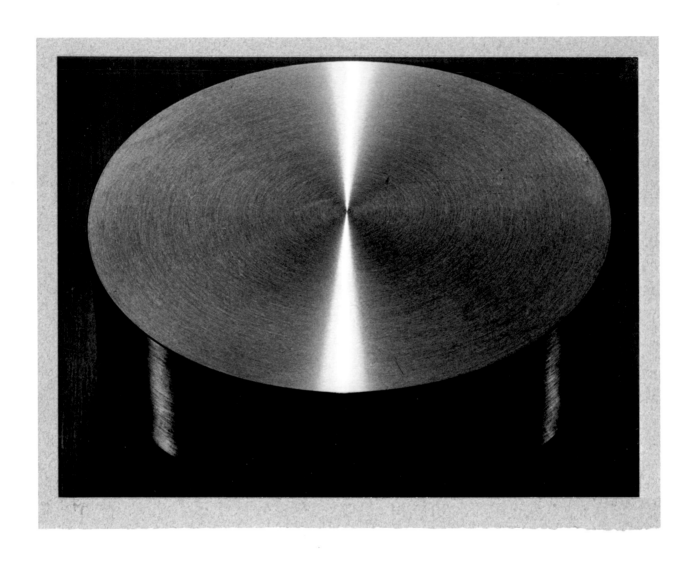

HAROLD HARVEY

Cylinder

Experimental color process, ca. 1935

◆

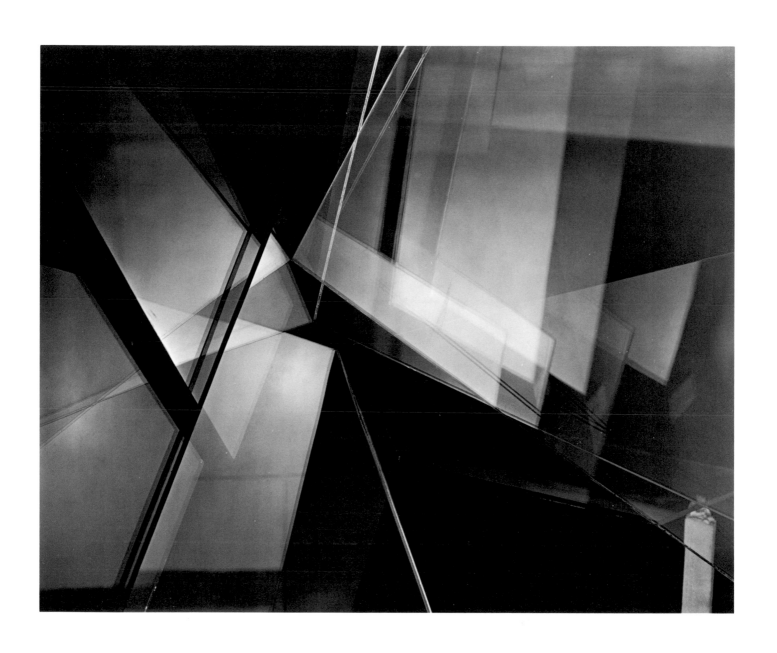

GRANCEL FITZ

Glass Abstraction

Silver print, 1929

◆

109

HAROLD HARVEY

Multiple: Woman

Silver print, ca. 1935

◆

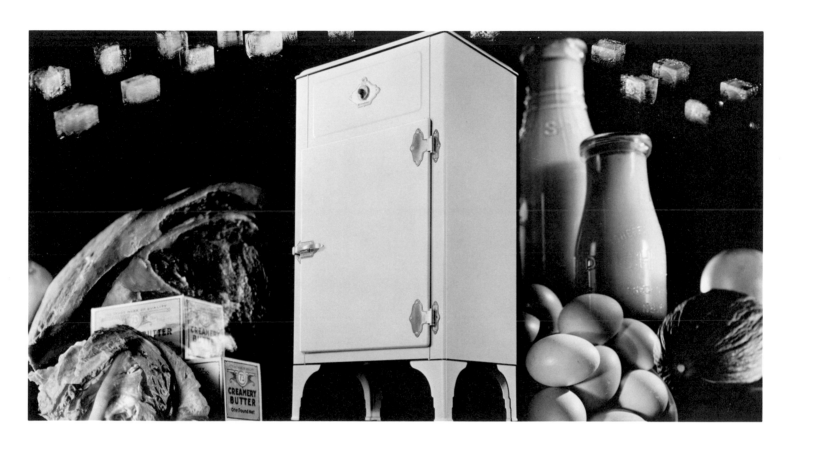

GRANCEL FITZ

The Ice Box

Silver print, ca. 1928

◆

111

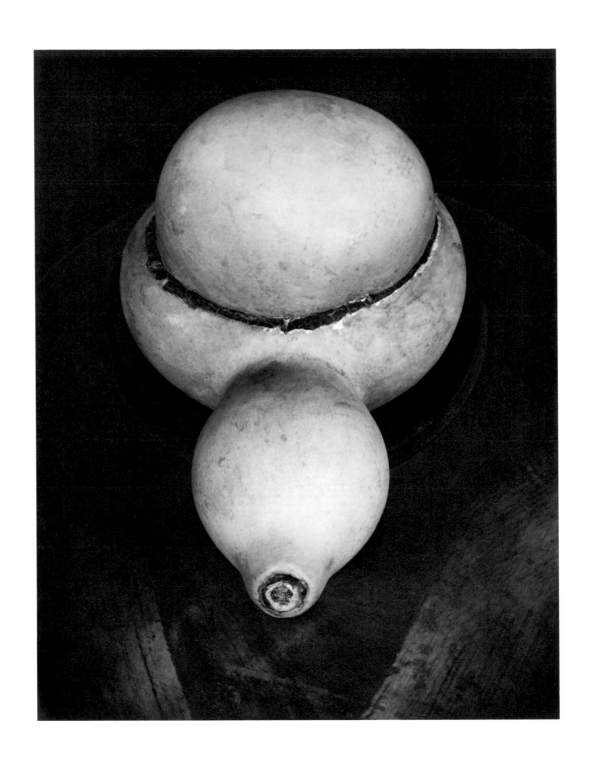

EDWARD WESTON

Gourd

Silver print, signed, 1927

◆

112

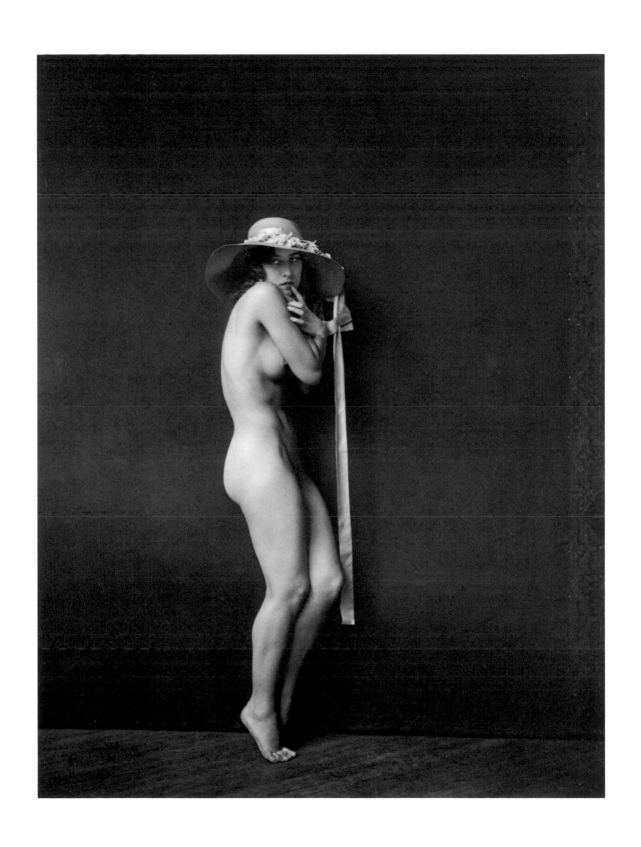

ALFRED CHENEY JOHNSTON

Albertina Vitak

Silver print, ca. 1922

◆

113

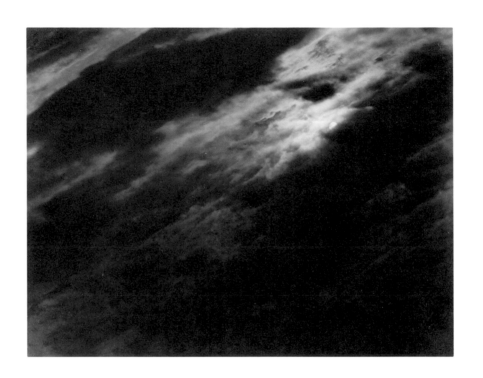

ALFRED STIEGLITZ

Equivalent

Silver print, 1927

◆

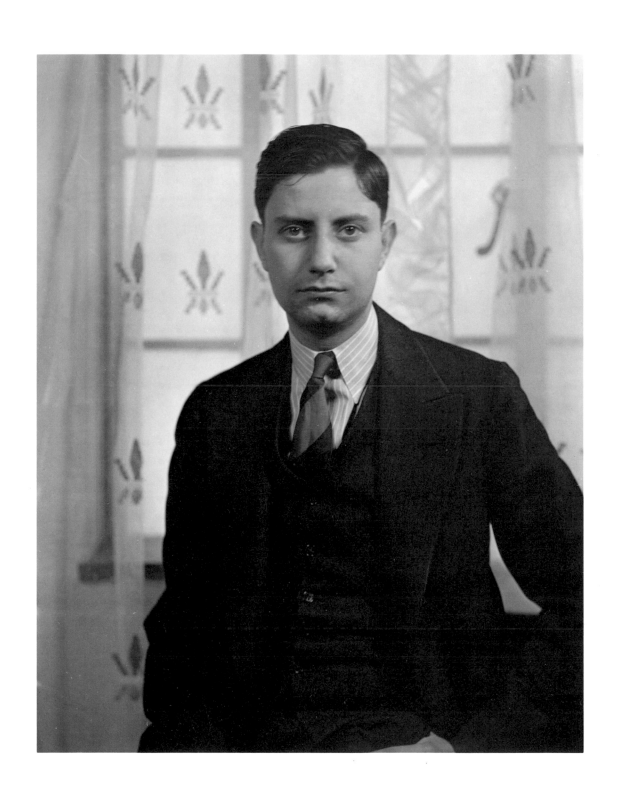

CHARLES SHEELER

Portrait of Maurice Bratter

Silver print, ca. 1928

◆

GRANCEL FITZ

Gershwin's Hands

Silver print, 1929

◆

116

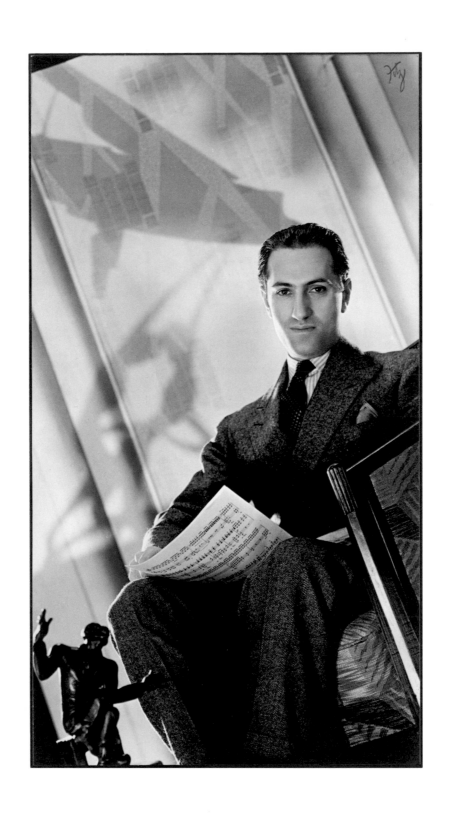

GRANCEL FITZ

George Gershwin

Silver print, 1929

◆

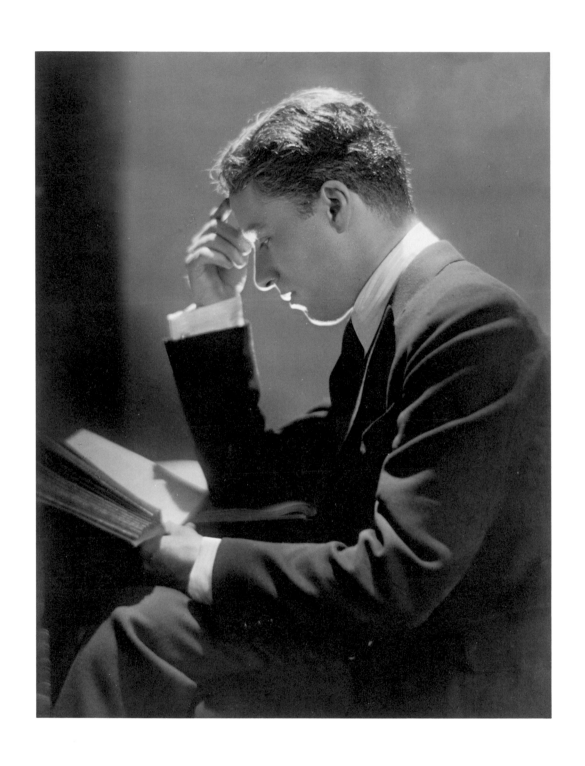

BARON ADOLPH DE MEYER

Portrait of Charlie Chaplin

Silver print, 1920

◆

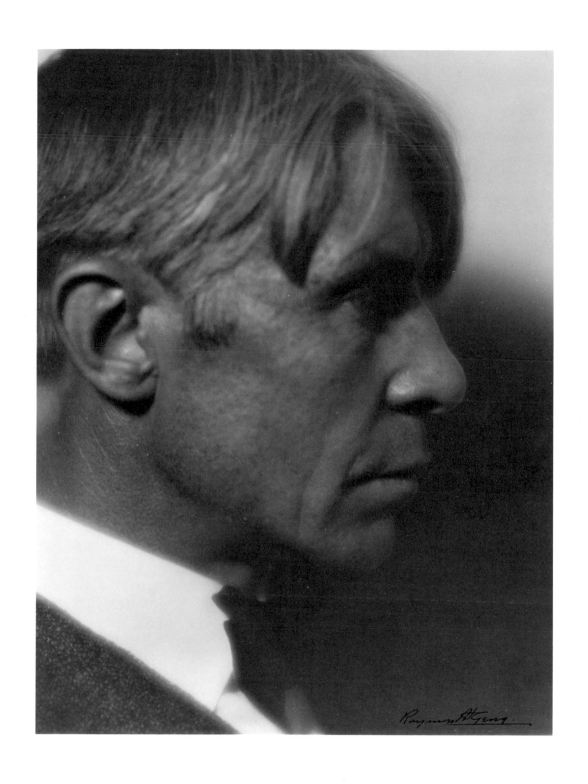

RAYMOND H. GEORG

Portrait of Carl Sandburg

Silver print, 1922-3

◆

119

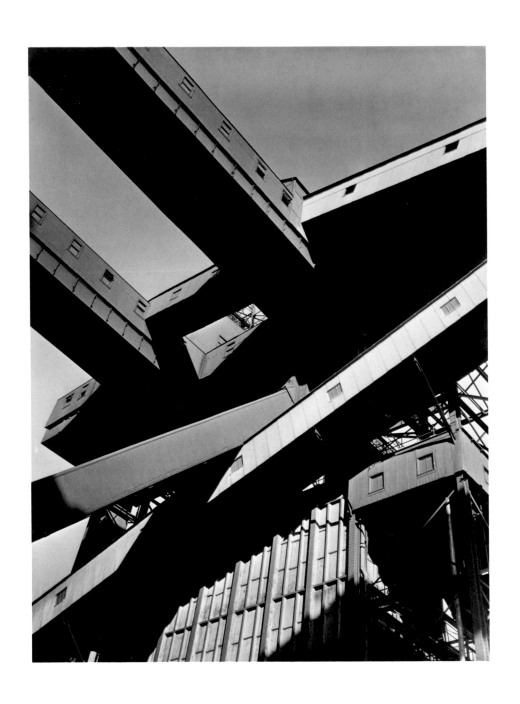

MARTIN BRUEHL

The Grain Elevators

Silver print, ca. 1932

◆

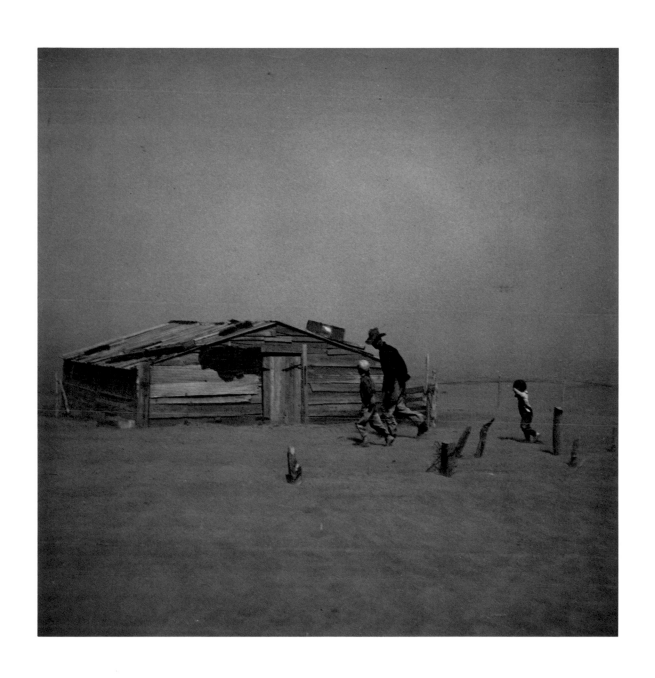

ARTHUR ROTHSTEIN

Dust Storm, Cimarron County

Silver print, 1936

◆

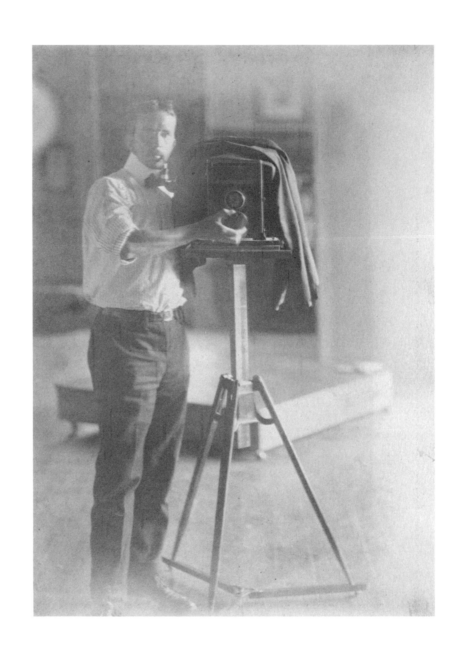

C. Yarnall Abbott

Self-portrait

Platinum print, ca. 1902

◆

BIOGRAPHIES OF PHOTOGRAPHERS/
NOTES ON THE PHOTOGRAPHS

The following entries are not intended to be exhaustive, but to provide an accurate and easily readable guide to the photographs. More emphasis has been placed on supplying little known information than on recounting the lives of well known photographers or familiar areas of their work. Except for daguerreotypes, all measurements are in inches.

UNKNOWN
City View
Daguerreotype
sixth plate
1839

This early daguerreotype would seem, on the basis of style, condition, presentation, and subject, to be one of the first to be done in America. It appears to be a view of Philadelphia similar to those done by Saxton in the first years of the medium. The crenellated building at right rear of the reversed composition appears in other views; the faintness of the image argues for an early date previous to mastery of the medium.[5]

UNKNOWN
Probably *James Forten*
Daguerreotype
sixth plate
ca. 1840

Forten (1766-1842) was a veteran of the Revolutionary War and wealthy manufacturer who amassed a large fortune. His sail factory employed both black and white artisans. In the early decades of the nineteenth century he was a leader in the movement against colonization, or the return of blacks to Africa, for which he led an important mass meeting in 1817. He was among the chief financial supporters of William Lloyd Garrison's *Liberator*, which published its first issue in January, 1831.[6]

ALBERT SANDS SOUTHWORTH (1811-1894)
JOSIAH JOHNSON HAWES (1808-1901)
Harriet Beecher Stowe
Daguerreotype
quarter plate
ca. 1843

The well known image of Harriet Beecher Stowe (1811-1896), author of *Uncle Tom's Cabin* (1851-2), and sister of Henry Ward Beecher, is often cited as a prime example of the work of Southworth and Hawes, among the best of America's first generation of daguerreotypists. The frequently reproduced example in the collection of the Metropolitan Museum of Art, having issued from the archives of the photographers' studio, represents a copy of record. The present example, long lost, would seem to originate with the family; as all daguerreotypes are unique objects, copied only by being rephotographed, the sitter and not the photographer would be expected to retain the choicest image from a sitting. Research indicates that the date for this image is considerably earlier than that generally cited. The work of the firm of Southworth and Hawes, of Boston, is among the best known and most widely reproduced of any American daguerreotypists.[7]

WILLIAM LANGENHEIM (1807-1874)
FREDERICK LANGENHEIM (1809-1879)
Charles Calistus Burleigh
Daguerreotype
half plate
ca. 1843

The Langenheim brothers opened a studio in Philadelphia in the early 1840s. Emigrating from Germany, William had arrived in this country in 1834, to pursue a military career, first in the Texas war for independence and later in the Florida Indian wars. In 1840 he joined Frederick, who had settled in Philadelphia. The brothers had brief careers on a German language newspaper before embarking on daguerreotypy. The Langenheims played a long and important role in the development of photography in America. Besides the daguerreotypes for which they are best known, they were pioneers in America of such technical innovations as the calotype and the glass negative. They are perhaps best known to the public for their early images of Niagra Falls.

Charles Calistus Burleigh (1810-1878) was a colorful abolitionist figure whose long red hair, falling in ringlets on his shoulder, was unusual even in its own day, and aptly suggested the intense, messianic nature of his mission. Born in Plainfield, Connecticut, he abandoned a promising career in law to work as an editor, writer, and speaker in the fight against slavery. He later espoused the cause of temperance and women's rights, and opposed capital punishment as well. Burleigh worked closely with William Lloyd Garrison (1805-1879); in one instance he is credited with saving his life from an angry mob. Two of Burleigh's brothers were poets; one was the author of a tribute to Fremont, the other was, like Charles, a longtime friend of Whittier.[8]

WILLIAM LANGENHEIM
FREDERICK LANGENHEIM
John Greenleaf Whittier
Daguerreotype
half plate
ca. 1843

This daguerreotype of one of America's major poets is the earliest of only two known to exist. Believed lost until discovered by Mr. Rinhart, the image had been known only in the form of engraved or lithographic illustrations for which it had served as the source. Like Charles Calistus Burleigh, Whittier (1807-1892) served as editor of the abolitionist *Pennsylvania Freeman*; both were, along with Harriet Beecher Stowe, prominent and articulate leaders in the abolitionist movement. The present daguerreotype shows us Whittier at a considerably younger age than he has been seen before. One can understand the fascination provoked by his military bearing and his dark eyes, which were commented upon by many, including his contemporary, Julia Ward Howe. These qualities, when seen in light of the life he lived—for he was a Quaker and a lifelong bachelor—made him a notably enigmatic figure in American public life.[9]

ALBERT SANDS SOUTHWORTH
JOSIAH JOHNSON HAWES (attrib.)
Black and White Hands on a Prayer Book
Daguerreotype button
1″ diameter
ca. 1847

Daguerreotypes were sometimes mounted, as this one is, in wearable form. But, although examples of brooches, cufflinks and other jewelry exist, no other case of a

◆

daguerreotype button with a loop for sewing is known.

Hands would seem to be the predecessor of the ubiquitous lapel "button" of our own day. It depicts a black hand holding a prayer book, with a white hand over it. It is clearly intended to represent abolitionist sentiments, and is thus one of the earliest examples of political symbolism in American photography.

The highly charged subject of *Hands* appears as the concluding image of Whittier's poem "On a Prayer Book." The poem was inspired by an incident in which in order to better market a prayer book, its frontispiece, *Christus Consolator*, by Ary Scheffer, was "Americanized" by the removal of the figure of a black. The relation between Whittier, the event, and the photograph is thus similar to the better known image by Southworth and Hawes, *The Branded Hand* on which Whittier also wrote.[10] The lines from "On a Prayer Book" are:

> *Lo! in the midst, with the same look He wore,*
> *Healing and blessing on Gennesaret's shore,*
> *Folding together, with the all-tender might*
> *Of His great love, the dark hands and the white,*
> *Stands the Consoler, soothing every pain,*
> *Making all burdens light, and breaking every chain.*

JOHN ADAMS WHIPPLE (1822-1891)
The Moon, August 6, 1851
Daguerreotype
quarter plate
1851

Probably the best known image by this pioneer Boston daguerreotypist, and one of the first astronomical photographs of any kind. The only other originals known to exist are in the collection of the Observatory at Harvard University, where they were taken, and at the Science Museum in London, which received an original and a copy from Herschel which had been sent directly to him by Whipple.[11] Another image which was shown in England at the Great Exhibition was later destroyed in a fire in Glasgow.

UNKNOWN
Child with American Flag
Daguerreotype

quarter plate
ca. 1856

The earliest known view of a child with an unfurled American flag.

RUFUS ANSON
General Ethan Allen Hitchcock
Daguerreotype
half plate
ca. 1857

General Hitchcock was the grandson of Revolutionary War hero Ethan Allen. For this portrait he visited the New York studio of photographer Rufus Anson, which was active from about 1851-1867.[12]

FREDERICK SCOTT ARCHER
(British, 1813-1857)
Self-portrait, Kenilworth
Salt print from collodion negative, signed
8¾ x 7
1851

Archer's collodion on glass process, developed by 1851, was one of the most important and far reaching advances in photography. As the basis of the wet plate process, it played an essential role in the work of a generation of America's most capable and original photographers.

Few of Archer's prints survive. The earliest are a set of albumen prints of a somewhat later date, printed by Archer's friend Jabez Hogg, and now at the Royal Photographic Society, Bath. That group includes a print of the present image. However, Archer is known to have exhibited earlier, at the Great Exhibition at the Crystal Palace, in 1851. Considerations of provenance and materials suggest that the present print is one of several views of Kenilworth he exhibited at that time. It is thus probably from among the first set of collodion photographs of any kind ever made or exhibited.

Self-portrait, Kenilworth was originally acquired, along with others of a group taken at the same site, directly from Archer at the time of the Great Exhibition. It formed a part of one of the earliest serious collections of photography in America, that of Charles Greely Loring, where it remained, until recently, unknown outside the family. No other salt prints by Archer are known to exist.

This British photograph is one of two included in the present selection because of its importance to an entire era of American photography, as well as its relation to several of the individual prints collected

here. It should be noted that while Archer played an important role in the development of photography, he benefitted little from his contribution, dying poor at an early age at the very time that his invention was transforming photography both in the New World and the Old.[13]

SAMUEL MASURY (1818-1874)
On the Loring Estate
Albumenized salt print, blindstamped
10¼ x 12¾
ca. 1856

Charles Greely Loring (1828-1902) was an artist, curator, and collector, and first director of the Museum of Fine Arts, Boston, whose interest in photography led him to form one of the first early collections of that art in this country. Masury, among the finest New England daguerreotypists, may well have learned through Loring's acquaintance with Frederick Scott Archer the wet plate process of which the present print is an excellent early example. Masury, who trained under pioneer daguerreotypist John Plumbe (1811-1857), had also visited Europe himself in 1855, studying with the Bisson Frères and acquainting himself with a number of other practitioners of his art. He was known in his day as a consummate artist and leading technical innovator in photography.[14] This image, taken on Loring's estate near Gloucester, Massachusetts, thus reveals not only a crucial passage in the history of photography, as it entered a new phase on a new continent passed from one master to another, but its growing place in the broader world of American arts as well. Both through its connection to Loring as curator, patron, and collector, and in its clear relation to the school of American genre painting best represented by William Sidney Mount, it is a pivotal piece of American art of its time. Inscriptions on the paper mount of this print identify its subjects; Loring, marked "CGL," is at center.

SAMUEL MASURY
Landscape, Pride's Crossing
Albumenized salt print
10 x 13¼
ca. 1856

This second image taken on the Loring estate again reveals the relation of Masury and Loring to the art of their time. As well as being an important early American paper print, the scene is linked to Kensett,

who painted a view from the same site. The print is from Loring's collection.

JOHN B. GREENE (ca. 1832-1856)
Algeria (Probably near Cherchelle)
Salt print from paper negative
9¾ x 12¼
1856

Little is known of Greene, who was the son of a Boston banker working in Paris. His first known work is a set of ninety-four prints taken in Egypt, published in France by the early photographic publisher Blanquart-Evrard in 1854. After a second trip to Egypt in that year, which combined archaeology and photography, he embarked on a similar enterprise late in 1855 to document Egyptian ruins in Algeria; the present print is from the resulting series of photographs. He died the following year in his early twenties on his third Egyptian voyage. Greene's photographs are not only documents, but show a strong interest in the aesthetic qualities of photography. His use of the more overtly sensual paper negative, and his unconventional choice of subject (his archaeological camp) make this image and print characteristic of his unusual and sometimes haunting work.[15]

SAMUEL ROOT
John C. Fremont, "The Pathfinder"
Salt print
8 x 6
1856

Fremont (1813-1890) was a quixotic public figure best known to Americans during the central years of the century. Explorer, general, financier, and politician: successful or unsuccessful, he was frequently in the public eye. As the first Republican presidential candidate he opposed Buchanan. He later yielded his hopes of a presidential nomination to Lincoln. Samuel Root had his gallery on Broadway, in New York, first with his brother Marcus (1811-1888) from 1849-51, and later on his own through 1857. He then moved to the Midwest, and continued as a photographer until 1878. Marcus, who had studied with the painter Thomas Sully and learned daguerreotypy from the pioneer Philadelphia photographer Robert Cornelius, was well known, exhibited widely, and was the author of an important treatise on photography.[16]

CHARLES RICHARD MEADE (1827-1858)
HENRY W. MEADE (1823-1865)
James Buchanan, Fifteenth President of the United States

Waxed salt print, blindstamped
6½ x 5
1856-7

The Meade Brothers are believed to have begun as daguerreotypists in upstate New York in the early 1840s. They were not only photographers but manufacturers of photographic materials and cases. They participated in exhibitions, including those of the Crystal Palace both in England and New York, receiving numerous medals and commendations both for artistic and technical excellence. Especially relevant to this image, they were adept at the calotype method, using paper photography before 1850. By 1852 they had a gallery with a number of assistants, and a large set of images. Henry worked in Europe as well as the United States. At the time of this image, the Meade brothers also introduced photographs on silk, a device of political and social relevance in popularizing the use of photography for purposes of publicity, advertising, and design.[17]

Buchanan (1791-1868), preceded Lincoln in the White House, and had the difficult task of guiding the nation through the years on the eve of the Civil War. Original portraits of Buchanan are extremely rare.

MATHEW BRADY (1823-1896)
Jeremiah Black, Statesman
Imperial salt print
19 x 15
ca. 1858

The powerful figure of Jeremiah Black, first Buchanan's Attorney General and later his Secretary of State, comes across strongly in this pre-Civil War salt print of the large size Brady favored for major portraits. Beginning as an itinerant painter in the Hudson Valley, Mathew Brady took up the daguerreotype under Samuel Morse, eventually going into the portrait business, as well as the manufacture of daguerreotype cases. His first historical enterprise was his *Gallery of Illustrious Americans*, a documentary effort to produce a series of engravings of public figures for general sale from daguerreotype portraits. This project was begun but never completed. Eventually he became the proprietor of galleries in New York and Washington which were among the finest and most influential anywhere. His galleries and Civil War work produced not only thousands of individual photographs, but helped to train many of the best photographers of the time.[18]

MATHEW BRADY
Literary Group (George Harding Bancroft, George Henry Boker, William Cullen Bryant, Bayard Taylor)
Salt print
11 x 14
ca. 1860

Literary Group is not only a good example of Brady's work in this genre, but also of his historical and documentary intentions, and sense of the public's desire for images of its cultural as well as political heroes. Of these well-known authors of the time, George Henry Boker (1823-1890) is today perhaps the least known. Poet, playwright, and diplomat, in the 1870s he was minister to Turkey and envoy to Russia. Bryant, poet, editor, and lawyer was among the best known men of his age. Bancroft and Taylor, although popular, have not survived as major figures. Bancroft was author of an ambitious *History of the United States*, a member of Polk's cabinet, and founder of the Naval Academy. Taylor's travel writings, which appeared both in journals and were later collected in book form, offer a wonderfully direct picture of his time.

EGBERT GUY FOWX (b. ca. 1825)
44th New York Encampment, Christmas Night
Albumen print
6 x 8 (oval)
1862

Fowx worked for Mathew Brady documenting battles along the James River, photographing at City Point and other key locations in the Union supply line. Notations on the back of the present print confirm that it derives from the archives of the Century Company, where it was reproduced in the 10 volume *Photographic History of the Civil War*, the standard reference of its kind. Fowx later maintained a studio in Baltimore in the 1870s and '80s. The oval treatment of the print creates a vignetted, sentimental quality appropriate to its Christmas setting.[19]

ALEXANDER GARDNER (1821-1882)
Camp Houses
Albumen print
7 x 9
ca. 1864

Gardner was a Scottish immigrant with previous photographic training, who began his work in this country as an assistant and then gallery director for Mathew Brady. During the course of the Civil War he broke

◆

away from his employer to set up a studio of his own. His *Photographic Sketchbook of the Civil War*, which includes views by Timothy O'Sullivan, George Barnard, and a number of other photographers, is a classic work; along with his portraits, and a substantial body of other work, it establishes him as one of the major figures in American photography. *Camp Houses* shows the permanent winter housing built by the union army, and exemplifies Gardner's strong sense of geometry and composition.[20]

MATHEW BRADY
71st New York State Militia,
The Naval Yard, Washington
Albumen print
9⅜ x 13⅛
ca. 1865

The maneuver being performed, called a "century," is of Roman origin. Brady's composition is an elegant arrangement which plays the slanted plane of the large roofed workshed against the level parade ground, shaping the large open space in which the soldiers and crowd have gathered.

LEWIS EMORY WALKER (1825-1880)
(attrib.)
Man and Mortar
Albumen print
10 x 14¼
1866

Walker was official photographer for the Treasury Department, and is best known for his series on the construction of the Treasury building, for which his earliest known work was done in 1858. He continued at the Treasury until his death in 1880, when his position was briefly filled by his friend and associate Timothy O'Sullivan. The photographer's skill and experience is certainly much in evidence in this elegant composition, in which circles of varying sizes lend interest to what would otherwise be a rather static, uninteresting subject.

WILLIAM BELL (1836-1902)
Private George Ruoss, Wounded Near Petersburg, March 31, 1865
Albumen print
7 x 9
1867

Bell was a Philadelphian who worked during the Civil War and later in the West. His series of medical photographs during the war was one of the first sustained uses of the medium for scientific documentation. The label on the reverse of the mount identifies Private Ruoss, and details the long history of his medical treatment. The image is No. 179 of the series, which was commissioned by the Surgeon General for the Army Medical Museum.

ALEXANDER GARDNER
While Judge Olin Was Delivering the Address
Albumen print
7¾ x 9¾
1865

This unusual view of a Civil War dedication ceremony is an early example of a documentary style, whose informality recalls the famous series on Grant's council of war taken by Gardner's assistant, Timothy O'Sullivan. Judge Olin was the principal speaker at the dedication of the monuments at the battlefields of First and Second Bull Run, which took place on June 10, 1865. The present photograph is probably from the dedication at Second Bull Run. General Heintzelman, who also gave an address, is visible in the foreground lifting his cap.[21]

ALEXANDER GARDNER
Portrait of Andrew Johnson, Seventeenth President of the United States
Albumen print, stamped
17 x 13¼
1865

This photograph, taken May 6, 1865, shortly after Lincoln's assassination, was reproduced a week later, on May 13, as a woodcut on the cover of *Harper's Weekly*. In it, Gardner's mastery of portraiture is evident in the straightforward approach he takes with his subject, and the presence he achieves for Johnson through clarity and a disarming simplicity unusual for the time.

JAMES WALLACE BLACK (1825-1896)
Edward Everett Hale and Son
Albumen print
8 x 5⅞
1869

Black was a prominent Boston photographer whose career began in the earliest years of the medium. He continued to photograph for some sixty years, through the rest of the century; his photographic business survived him, and continued until 1901. Black had a number of partners, but is probably best known for his association with John Adams Whipple; along with Southworth and Hawes, Black was one of Boston's preeminent photographers throughout an entire era. Concerning the present view, although it appears to be a standard studio genre scene, the *Philadelphia Photographer* noted that the subject is in fact the famous clergyman and writer Edward Everett Hale (1822-1909), who has contrived to use photography to make light of a well known engraving of the time. Hale was the author of the much anthologized story "The Man Without a Country," and the nephew of the orator Edward Everett, who spoke before Lincoln at Gettysburg.[22]

UNKNOWN
Divers, Kansas City Bridge
Albumen print
7 x 9
ca. 1869

This photograph, whose label identifies it as "Crew of Divers, at Pier No. 4, March 2d, 1869," is one of fourteen original prints bound into an author's copy of *The Kansas City Bridge*, published by D. Van Nostrand, New York, in 1870. The book is an account written by the project's chief engineers of the progress and methods of building a large bridge over the Missouri River, whose shifting bottom and other engineering considerations made its completion an especially challenging task. It has been thought that this series of photographs may have been taken by William James Stillman, the American photographer of the Parthenon, and intimate of Rossetti and others of Ruskin's circle, but to date no documentation of this has surfaced, and at present it seems unlikely. Whoever the photographer, the series provides an early example of the documentary approach, and gives us a good picture of the high technology of the day. The names of the divers are listed in the book's appendix among others who worked on the bridge.[23]

ALEXANDER GARDNER
Railroad Station, Wamego, Kansas
Albumen print
7 x 9¼
1866

Like several other important photographers, among them Timothy O'Sullivan, A.J. Russell, and William Bell, Gardner took work in the West after the close of the Civil War. This print, and the following, are from a series done for the Union Pacific Railroad, documenting and publicizing its progress West of the Mississippi, published in albums entitled *Across the Continent on the Union Pacific Railroad.*

The stark style and new construction of

◆

this station indicate the youth of the small settlement it served, halfway between Topeka and Abilene. Note the new plow sitting in the shadows ready for delivery.

ALEXANDER GARDNER
Self-portrait Along the Route of the Union Pacific Railroad
Albumen print
7 x 9¼
1866

Self-portrait, also from Gardner's *Union Pacific* album, with its windblown trees, has an almost stylized, elegaic tone reminiscent of some of the quieter moments of the best Civil War photography.

UNKNOWN
Bridge Across the Mississippi River
Albumen print
13 x 22
ca. 1878

Bridges, railroads, and other facets of engineering and architectural growth were popular subjects for the photographer in a nation which was growing and expanding after the Civil War. A number of examples are known which show the testing of bridges, as we see here, by loading them with the heaviest available objects: railroad engines. The crowd which has gathered to witness the event, despite apparent rain, indicates that it was an occasion popular with the public as well.

CARLETON WATKINS (1829-1916)
Cape Horn, Near Celilo
Albumen print, dated, stamped
16¾ x 20¾
1867

Watkins' Columbia River series of 1867 is a benchmark in American photography. Although probably commissioned by the Steam Navigation Company, as individual images the works are representative of Watkins' larger effort to portray the Pacific Coast and large areas of the Far West in marketable photographic views of high aesthetic quality. As prints they are among the finest ever made. As a series they constitute a narrative of a voyage on a great American river. Watkins came West to California in 1851. He began working in photography in about 1854, first in the studio of Robert Vance and later that of James Ford, pioneer daguerreotypists in the San Francisco area. By the late fifties he had taken up the wet plate process, producing in 1861 his first series of mammoth plate views of Yosemite, classics of the

art, on which he based his early reputation.

Cape Horn, from the Columbia River series, is one of Watkins' best known images. Its appeal to the modern eye is so strong as to have caused one recent writer to deem it the single most beautiful photograph of the entire century,[24] a claim probably no individual work, however fine, should be asked to support. It is, however, a masterful performance; its fine play of surfaces and textures lend it an almost palpable air. The present print is unusual in that the negative has not yet been worked, as it was for later printings. It is an early print, and bears not only Watkins' 1867 copyright stamp, but his handwritten numbering as well.

WILLIAM BELL
Looking South into the Grand Canyon of the Colorado River at Sheavwitz Crossing
Albumen print, dated and labelled on mount
10¾ x 8¼
1872

Bell replaced O'Sullivan on the Wheeler survey during 1872, the year in which this picture was taken. Like O'Sullivan, he was a veteran of Civil War work. The Grand Canyon exemplifies the new, dramatic land and spaces faced by American photographers in the West.

TIMOTHY O'SULLIVAN
Black Canyon, Arizona, Wheeler Survey
Albumen print
8 x 10¾
1871

O'Sullivan was of Irish parentage, and grew up on Staten Island. He trained first with Mathew Brady, and later joined Alexander Gardner when he left Brady's employ to set up a studio of his own. He was one of the most important photographers of the Civil War, providing over forty negatives for Gardner's *Sketchbook*—nearly half the total, as well as numerous other images. After the war, O'Sullivan worked with the Western surveys sponsored by the federal government, among them Clarence King's Fortieth Parellel Survey, and Lt. George Wheeler's Survey West of the Hundredth Meridian. In 1870 he interrupted his work in the Far West to accompany Commander Selfridge's Darien Survey, to Panama, searching out a proposed route for an isthmus canal. In 1880 he became photographer to the Treasury, replacing his colleague and friend Lewis Emory Walker.

This view is from one of O'Sullivan's best known series. Wheeler and King were in competition for control of the Western surveys. Both used photography as a tool for promotion, as well as for documentation and research, giving O'Sullivan's work considerable public exposure. *Black Canyon* shows O'Sullivan's direct, unadorned style in which the land and not the photographer is prominent.

CHARLES SAVAGE (1832-1909)
Dodge's Bluff, Canyon of Grand River, Rio Grande Western Railroad
Albumen print, labelled in negative
18 x 22
ca. 1881

Savage was an English born photographer working in Salt Lake City. This view of Dodge's Bluff is part of a larger series done for the Rio Grande Western Railroad. The grandeur of its landscape helps to explain the railroad's motto, printed on the mount of each photograph: "The Scenic Line of the World." Its composition makes it an interesting complement to Watkins' *Cape Horn, Near Celilo*.[25]

WILLIAM HENRY JACKSON (1843-1942)
Gunnison Butte, The Green River, Utah
Albumen print, labelled in negative
16¾ x 21¼
1876

Although he outlived most of his professional contemporaries to become something of a living legend among photographers, Jackson was a member of the first generation to do wet plate work in the West. He began first with a studio of his own, operated with his brother, in Omaha in 1867. He later worked for the survey of F.V. Hayden, and eventually had a large photographic business making use of his many plates and negatives. His popular biography *Time Exposure* reveals not only his work in photography, but his interest in drawing and writing as well. *Gunnison Butte* is typical of the large size and excellent printing for which Jackson is known; the image is atypical in being perhaps less static and formal, and more fluid and natural, than others he commonly produced.[26]

TIMOTHY O'SULLIVAN (1840-1882)
Wagon in Desert, King Survey, Nevada
Albumen print
7⅞ x 10⅜
1868

Wagon in the Desert again exemplifies O'Sullivan's spare, almost minimal style.

◆

His disregard for prevailing artistic convention allowed him to develop a style more suited to photography, possibly the most influential single style to emerge from his era.[27]

CARLETON WATKINS
Oregon Steam Navigation Company Works,
Dalles City, Columbia River
Albumen print
16 x 21
1867

This view of Dalles City, also from the Columbia River series, shows Watkins' characteristically delicate control of lights and darks, and his ability to create through subtleties of composition an engaging geographical portrait from a minimum of resources.[28]

GEORGE BARKER (attrib.)
Niagra in Winter
Albumen print
13¼ x 16¼
ca. 1876

Despite a varied career, Barker, who was active in the 1870s and '80s, is best known for his views of Niagra, a site which attracted many photographers, both American and foreign, from the first days of the medium.

UNKNOWN
Ivory Soap
Tintype
4¾ x 6½
ca. 1880

This is the first known appearance of this well known product in a photograph. As in a daguerreotype, it appears here in mirror image. This tintype probably served as a model for a published print advertising the product. The subject seems to be a sales team.

DAVID W. BUTTERFIELD (1844-1933)
Dover Neck, New Hampshire
Albumen print, titled on mount
15½ x 22
ca. 1875

Large-scale Eastern wet plate landscape work is rare, and forms an interesting parallel to the better known work in the same medium in the West. *Dover Neck*, by David Butterfield, a Boston photographer active after the mid-1860s, is a view of the site of the first meeting house in New Hampshire, built in 1633. Barely visible are

the ruins of a later building which occupied the same site. An exhibition label indicates that this print was shown at the Centennial Exposition in Philadelphia, in 1876.[29]

DAVID W. BUTTERFIELD
Mills of the Winona Paper Company,
Chicopee, Massachusetts
Albumen print, blindstamped
17 x 22
ca. 1875

Butterfield brings out the architectural dignity and strong physical presence of this industrial subject, whose understated label says simply: "Daily Capacity, 12 Tons."

JAMES H. (JIMMY) HARE (1856-1946)
First Aerial Photo of New York, from Balloon
Silver print
7 x 9
1906

Jimmy Hare, one of the first photojournalists, was born in London, the son of one of the finest English camera makers. He left school in 1871 to become an apprentice in the business, and worked in England in camera making until hired away by E. & H.T. Anthony & Co. of New York in 1889. Within a few years Hare turned from manufacturing cameras to using them, an extension of the hobby to which he had become devoted earlier in England. In 1895 he succeeded Joseph Byron, of the noted photographic family, as a full-time news photographer at the *Illustrated American*, in New York. Shortly thereafter, his photographs of the wreckage of the "Maine" in Havana harbor and coverage of the Spanish American War initiated a long national and international career which produced images of many of the important people and events of his time. Among them are the Russo-Japanese War, the Mexican Revolution, and the First World War, as well as numerous less well remembered events. Hare developed many of the habits and techniques which have come to define the new profession of photojournalism, learning to use the hand-held camera his father had despised as a corrupt novelty to capture the sense of immediacy that transformed the esthetics and use of the photography.

Although James Wallace Black's early first aerial view of Boston is well known, Hare's later first views of New York are not. As an amateur and later as a news photographer, Hare covered many of the first de-

velopments in aerial flight, beginning in England as early as 1884. His balloon flight over New York, one of many assignments in a long association with *Collier's* magazine, was typical of his inventiveness and pluck. Although the balloon was finally launched after much difficulty from Staten Island, and the photographs, of which this is one, taken, the attempts of the aerialists to land on Long Island were frustrated, resulting in numerous dips of the basket and its human contents into Flushing Bay. Of Hare's plates, only about six were saved. They were printed after being carefully soaked and pried apart on his return home, after his rescue from the foundering balloon.[30]

FRED W. GLASIER
A Stellar Group
Platinum print, signed and dated
7½ x 9¾
1903

Little is known of Glasier, presumably a professional photographer who may be the self-possessed young man with a camera at the left. The direct documentary style of *A Stellar Group* brings to mind the work of August Sander (1876-1964), who is best known for his photographic catalog of German life.

WILLIAM H. RAU (1855-1920)
Penn Haven Junction
Albumen print, labelled in negative
17 x 20
ca. 1888

Rau was a Philadelphian who had had previous expeditionary experience in photography, both in the United States and abroad, before returning to his home city to open a studio with his brother in 1885. During the eighties he was a professional portraitist, and exhibited privately in salons as well. In the nineties he had several important railroad commissions, from which some of his best known work derives. His late mammoth plate albumen prints on this subject, such as *Penn Haven Junction*, form a vital link between early and late railroad photography, and between work in the East and the West. He is an important member of the second generation of American documentary landscape photographers, and was the son-in-law of the earlier photographer William Bell. Rau's wife, Louise Bell, was also a photographer.[31]

◆

UNDERWOOD AND UNDERWOOD
Society Ladies at Annual Horse Show,
Newport, R.I.
Silver print, stamped and labelled verso
7 x 8½
1913

The firm of Underwood and Underwood began as a small Midwestern studio, and grew to become one of the largest of the early photoagencies, playing an important role in the growth of photography as a tool in reporting and journalism. Notes on the back of the photograph identify its female subjects as Mrs. Stuyvesant Fish, Miss J. Johnson, and Mrs. J. Fred Pearson. The dapper gentleman in the boater is not identified.

FRANCIS BLAKE (1850-1913)
Pigeons in Flight
Platinum print, blindstamped
8 x 6
ca. 1888

Blake was a wealthy scientist, inventor, and engineer whose photographs of motion rival those of his better known and somewhat older peer, Eadweard Muybridge. Born in Needham, Massachusetts to an old New England family, Blake left high school at 16 to work on the U.S. Coast Survey. For the following twelve years his work took him to various points in the United States, Cuba and Europe; his principal duties were to carry out the astronomical observations and calculations to determine permanent points of latitude and longitude. He also served as astronomer on the Darien expedition directed by Commander Selfridge to investigate possible routes for a canal across the isthmus of Panama, as well as on the commission to fix the boundary between New York and Pennsylvania in 1875.

In 1878 Blake resigned from the Coast Survey to devote himself to electrical research. The best known result of his work is the Blake Transmitter, a practical device crucial to the development of the telephone. In 1873 he married Elizabeth Hubbard, and in 1878 became a director of AT&T, thus joining both the extended family and business circle of Alexander Graham Bell. Blake's interests were numerous. Besides the Boston Camera Club, and the National Geographic Society, he was a member of various scientific and engineering groups, as well as associations devoted to archaeology, folklore, and forestry. He was thus as an amateur photographer with a wide-ranging technical and geographical background which ties him to other practitioners of the time.[32]

FRANCIS BLAKE
Man on Bicycle
Platinum print, blindstamped
8 x 6
ca. 1888

JAMES H. (JIMMY) HARE
Orville and Wilbur Wright with Plane
Silver print
5 x 7
1908

Hare was the first photographer to publish a picture of the Wright brothers in flight. On assignment from *Collier's*, he joined a small but hardy group of reporters in the wilds of the North Carolina coast, in 1906, hiding in the dunes without the knowledge of the publicity shy young inventors, until a flight of the frail machine could be witnessed. When it finally became airborne, on a flight of several miles, Hare captured it in an image which was published soon after in the magazine, informing the American public that manned flight was no longer a myth but a reality. Hare covered later tests as well, including the fatal flight of Lieutenant Selfridge at Ft. Myer, Virginia, the site of the present image. By the time this photograph was taken, two years after his first, the brothers were well acquainted with Hare and his work. Orville, who sits in the plane, is said to have been a particular admirer of the enterprising photographer, who shared with him some of the adventurous spirit which is an important aspect of the turn of the century mood in America.[33]

UNKNOWN PHOTOGRAPHER, ALLIED EXPEDITIONARYFORCES
Aerial Photographer and Plane
Silver print, labelled in negative
6½ x 9
1918

Information on the negative identifies these figures as Capt. Fred Place, Director, and Lieut. James G. McNett, Assistant Director of the Aerial Photography School. Note the hole in the body of the airplane for taking photographs, and the pilot in black at the front. The photograph is simultaneously documentary and didactic, showing the elements of the process it illustrates. Both in concept and technique it speaks well, professionally, for the subjects it represents.

C.M. GILBERT
Chat-about-the-Hand (Joe Jefferson and Helen Keller)
Silver print, stamped, dated
8¾ x 7
1902

This photograph, taken by the professional portrait photographer C.M. Gilbert, of Washington, D.C., was an illustration for an article in the Century Magazine. An inscription on the mount shows that it passed through the hands of the important collector Frederick Meserve, who noted on it that he bought it in 1915. While Helen Keller is familiar to us today, Joe Jefferson, who is not, was a well-known American actor of the nineteenth century, an early celebrity much photographed in his various popular roles. Keller's youth and Jefferson's age make this an interesting historical meeting.

GEORGE C. COX (d. 1902)
Portrait of Edward MacDowell
Albumen, blindstamped
9½ x 8
ca. 1888

MacDowell (1861-1908) was an important and innovative American composer, and patron of the arts. Cox was a New York photographer now best known for his portraits of Whitman. The quiet simplicity of this likeness recalls the straightforwardness of Eakins and the planar quality of Whistler's famous portrait of his mother. The delicacy with which Cox has delineated MacDowell's features, the richness of tonal range, and the classic simplicity of the composition make this one of the finest of American portraits. Certainly Eakins himself would have enjoyed a work whose refined realism was so much like his own.[34]

WILLIAM WILLIS (British, 1841-1923)
Cottage Scene
Platinotype, 1878 process
9⅜ x 12
1878

One of the earliest platinum prints by the inventor of the process which was to be widely used by Americans. The present print is inscribed: "Developed before the Photographic Society of Great Britain to illustrate a paper read in December, 1878," and so was made in the year of the invention of the process, which had been preceded by a related patent in 1873. Willis was the son of a well known engraver; the print comes directly from his family. Platinum printing was far more stable than

silver, giving a longer lasting print. Its delicate tones were preferred by many photographers. It went out of common use due to increases in the cost of the material.

EMA SPENCER (1857-1941)
Girl at Table with Peaches
Cyanotype, inscribed on mount
5 x 7
ca. 1900

Spencer was born and worked in Ohio, where she had a home and a business in Newark. She studied under Clarence White (1871-1925), whom she had originally encouraged, having met the young photographer through his membership in the Newark Camera Club, of which she was a founder. Spencer exhibited both nationally and internationally, winning awards in Italy in 1902 and in Germany in 1903 and 1911. She participated in the Montross exhibition, and her work was reproduced in *Camera Work*. Among her other interests, she was a columnist for the Newark Advocate, and a trustee of the New York Public Library. *Girl at Table with Peaches* is reminiscent of the gentleness we find in the style of White; its quiet domestic tone links her to Kasebier as well.

WILLIAM B. POST (1857-1925)
The Critic
Platinum print
5⅞ x 7⅜
ca. 1893

This photograph of Alfred Stieglitz with the artist Frank Hermann was taken in the same year he wrote about Post in *American Amateur Photographer*, the magazine of which he had recently become editor. The previous year Post had introduced him to the hand camera. Post began photographing before 1889, and exhibited steadily in the period between 1894 and 1910. He was a member of the Camera Club of New York and Fellow of the Photo-secession.[35]

GERTRUDE KASEBIER (1852-1934)
The Wedding
Platinum print
8 x 6
1899

Gertrude Kasebier was born in Des Moines, Iowa and grew up near the mining town of Leadville, Colorado. She attended college in the East, and in the late 1880s entered Pratt Institute in Brooklyn as a student of portrait painting. She soon became involved in photography, winning an award in a competition as early as 1892. She later studied photography in Germany, and in 1897 opened a successful portrait studio in New York.

Kasebier reached prominence in 1898 with the inclusion of ten prints in the first Philadelphia Photographic Salon. Her work was highly praised in a review by Joseph Keiley. The following year, her image *The Manger* brought the highest price to date of any Pictorialist photograph, and she was publicly acknowledged to be the leading figure among portrait photographers in America. Kasebier went on to exhibit widely and to participate in several influential photographic groups of the time. She was a member of the Camera Club of New York, as well as of the exclusive Linked Ring. An associate of F. Holland Day, Steichen, and Clarence White, she was a founder and fellow of the Photo-secession; numerous gravures of her photographs were published in *Camera Work*. In 1910 she exhibited 22 prints in the important Pictorial exhibition at the Albright Gallery in Buffalo. Among her other professional associations, she helped to found the Pictorial Photographers of America, in 1916. Her last exhibition was held in Brooklyn in 1929, the year in which she ceased operating her studio.

The subject of *The Wedding* is the marriage of Mrs. Kasebier's daughter, Gertrude. The photograph combines Kasebier's professional competence with the sense of personal concern for her subjects characteristic of her work—subjects often drawn, as here, from her circle of family and friends.[36]

ALVIN LANGDON COBURN (1882-1966) or
WILLIAM ORISON UNDERWOOD
(1873-1947)
The Mill at Ipswich
Gum and platinum
9¾ x 7½
ca. 1902

Underwood was a cousin of the better known Coburn. He was a member of the Photo-secession, participating in the first members' exhibition at the '291' gallery. He also held a solo exhibition of his own work in Boston. *The Mill at Ipswich* is a tour de force in the gum process, much resembling the works in charcoal to which many photographers of the era looked as a source of inspiration. Because the two photographers worked closely together, and because *The Mill at Ipswich* was found unsigned among Underwood's papers, its attribution is still uncertain. Coburn was a Bostonian who joined the Photo-secession in 1904. An important and influential photographer, he spent a considerable portion of his time working in England and Europe, where he was associated with Shaw, Wells, Pound, and others whose portraits comprise his series *Men of Mark*. Among the important Americans he photographed were Mark Twain, Henry James, and Gertrude Stein.

DR. RUPERT S. LOVEJOY (1885-1975)
Finale
Multiple gum print
13 x 11
1916

Dr. Lovejoy was a well-known Pictorialist from Portland, Maine. He exhibited both in the United States and Britain, showing works in the San Francisco Salon of 1916, in the London and Los Angeles Salons of 1917, in several exhibitions of the Pictorial Photographers of America in 1918, as well as others. An enthusiastic critic wrote in *Photo-Era*, 1923:

"Dr. Rupert S. Lovejoy is well known through his contributions to all the principal exhibitions in the United States, and the London and Royal Photographic Salons. At a recent photographic competition and exhibition at Kansas City, he won first prize in a total of more than eight hundred accepted prints. He is ... a member of the Pittsburg and Los Angeles Salons ..."

F. HOLLAND DAY (1864-1933)
Pepita
Platinum print
6½ x 4¾
ca. 1896

Born and educated in the Boston area, F. Holland Day was a publisher of independent means for whom photography was one of a number of varied and passionate interests. A champion of Aubrey Beardsley and an early admirer of Keats, whose work he helped bring to the attention of the public, he was friend to John Lane, William Morris, Oscar Wilde, and others of advanced thought of his time. His role in American photography is great. Along with Stieglitz, with whom he developed a rivalry, he is credited with greatly improving the standing of the medium as an art form. His exhibition of American photographs at the Royal Photographic Society in London in 1900 included 375 prints, of which over one hundred were his own work. His series on

◆

the last days of Christ, a project which required over a year of preparation and three months to photograph, was attended by much notoriety, its serious intent finally outweighing its unusual content and form. His use of nudity and black models in his photographs was controversial. Although most of Day's work was lost in a fire in 1904, the remaining pieces, such as *Pepita*, amply reveal the delicate sensibility and high technical skill which he brought to all his work.[37]

BERTRAM H. WENTWORTH (1868-1955)
Cholla
Platinum print
3¾ x 4⅜
ca. 1896

Wentworth was born in Gardiner, Maine, and worked in banking first in Maine and then in Chicago, before his health forced him to seek a different climate and more active forms of work. From 1894 to 1906 he was in the Southwest, holding a varied series of jobs, from prospector and railroad laborer to bank clerk. He later returned North to manage a gypsum quarry, and eventually to take up residence again in Gardiner, keeping a studio on Monhegan Island as well. Wentworth was interested in photography throughout his life, taking it up in a serious way after 1913, perhaps under the influence of W.H. Jackson, for whom he had previously worked. He exhibited widely and received excellent critical response. He was best known for his landscape and marine work, and wrote frequently on aesthetic and technical matters in photography. His photographs were often reproduced. Exhibitions of his work were held at the New York Camera Club, and the Corcoran Gallery, as well as in Philadelphia, Boston, Cleveland, Columbus, and other cities.[38]

GERTRUDE KASEBIER
The Red Man
Gum over platinum, signed
8 x 6
1901-2

This print of *The Red Man*, one of Kasebier's best known images, is her own exhibition print. Presumably its hand painted mat and frame reflect the way in which she wanted the work to be seen. It was exhibited at the Albright Gallery show of 1910, and without doubt in other exhibitions as well.

CLIFTON JOHNSON (1865-1940)
John Burroughs
Albumenized silver print
4⅞ x 6⅞
ca. 1895

Clifton Johnson was a widely known illustrator, writer, editor, and photographer from Hadley, Massachusetts, whose many published works, from 1890 to 1938, a number of them on travel, include two volumes on Berkshire County. He left school at fifteen to work in a bookstore, and later studied at the Art Students' League in New York. He was an inveterate hiker. Burroughs was one of numerous authors whose works he illustrated; others include Thoreau, Howells, Dickens, and a host of other writers both contemporary and classic. Johnson's picture of Burroughs, with whom he frequently worked, seems to place him in the environment he loved best. Its relaxed tone, embodied in Burroughs pose, in the dog at the left, resting but alert, and in the Adirondack style furniture characteristic of the mountains of the West as well as of the East, seems indicative of American informality and comfort in the outdoors.

GERTRUDE KASEBIER
Happy Days
Platinum, signed
8 x 6
1902

Summertime and *Happy Days*, which was reproduced in *Camera Work*, clearly reveal the ability to capture elements of childhood innocence and domestic life which is central to Kasebier's work.

GERTRUDE KASEBIER
Summertime
Platinum on tissue, sepia toned
10 x 12
ca. 1910

DWIGHT A. DAVIS
Little Girl with Parasol
Platinum print
9½ x 7¾
ca. 1904

Dwight A. Davis was a Worcester, Massachusetts photographer widely recognized as one of the fathers of American Pictorialism. He was a founding member of the Pictorial Photographers of America, along with Clarence White, Gertrude Kasebier and others, and a member of the Council of Forty, representing Massachusetts. He exhibited at the Second Amer-

ican Salon (New York), 1905, and had four prints in the Montross show, 1912. He shared a loan exhibition at the Brooklyn Institute of Art with Arnold Genthe, in 1913. Davis's work was reproduced in *Photo-Era* and other journals of the day. The play of light and shade, and the star shaped shadows of leaves on the scalloped parasol, make this a striking and unusual Pictorialist portrait.

ALBERT ERNEST SCHAAF (1866-1950)
The Race
Oil pigment print
8 x 10
1905

This view of an automobile race in Auvergne is indicative of Schaaf's lifelong interest in movement and machines. Raised in Buffalo, New York, Schaaf had a long career in racing, manufacturing, and selling bicycles before moving with that industry, at the turn of the century, into its involvement with the fledgling development of the automobile. He was later a manufacturer and distributor of automobiles, becoming a director of FIAT's operations in the United States, as well as an independent industrialist. Schaaf began photographing in 1885. His prints were much admired, their Pictorial style and use of the oil technique leading some to compare them to paintings and prints. His photograph of a sloop, *The Greenwich Reach*, appeared on the cover of *The Photographic Journal of America* in 1915.[39]

JOHN CHISLETT (1856-1938)
Trees
Platinum print
9⅜ x 7¼
ca. 1904

Chislett was an important American Impressionist photographer working in Indianapolis from about 1895 to 1910. He was a close associate of Curtis Bell, the leader of the American Pictorialists, an "anti-Stieglitz" group. Chislett exhibited at the first American Salon in New York, in 1904, and continued to exhibit widely through 1910. He was an early friend and mentor of George H. Seeley, visiting Stockbridge to persuade Seeley to exhibit in the first American Salon, his first major exhibition. Chislett's work won numerous awards, and was widely reproduced in the photographic journals of his day—except those under influence of Stieglitz. His prints are now

◆

rare; none are known to be in any public collection.

DWIGHT A. DAVIS (1852-1943)
A Pool in the Woods
Gum over platinum, signed
12½ x 10¼
ca. 1906

A Pool in the Woods is a fine example of American Pictorialism; labels on the reverse of the mount show that it was exhibited extensively. The similarity of its composition to that of his *Little Girl with Parasol* is striking.[40]

GEORGE H. SEELEY (1880-1955)
Landscape
Gum over platinum, signed and dated
17½ x 21½
1912

Seeley was born in Stockbridge, Massachusetts, and lived there throughout his life. After high school, he studied art, becoming the art teacher for the Stockbridge Public Schools from 1902-4. Although Seeley learned photography during his high school years, he was inspired to take it up seriously after a visit to the studio of F. Holland Day, in 1902. In 1903 his *Early Morning* won a First Prize from *Photo-Era* magazine. By 1904 Seeley was contributing fourteen prints to Curtis Bell's First American Photographic Salon, and was invited by Stieglitz to join the Photo-secession. In 1905 *Photo-Era* commented, "He is generally considered the photographic art find of the newer generation." The following year Seeley had two gravures in *Camera Work*, and five prints at the first exhibition of the Photo-secession. He was represented by twenty-three prints at the important Albright Gallery exhibition organized by Stieglitz in 1910, but photographed little after 1920. *Landscape* exemplifies the powerful simplicity of Seeley's style.[41]

WILLAM B. POST
Intervale, Winter
Platinum print, signed
7¼ x 9½
1898

Post, who spent a great deal of time in Maine, was considered a master of winter scenes. This image appeared as a full page photogravure in *Camera Notes*.

WILLIAM JAMES MULLINS (1860-1917)
The Lifeboat
Silver print
3¼ x 2¼
ca. 1899

Mullins was born in Steubenville, Ohio and became a chemist for Standard Oil. His interest in photography dates from the 1890s. He was a member of the Photo-secession; he exhibited at the first members' exhibition at the '291' gallery, and showed twelve prints at the Albright Gallery exhibition of 1910. He participated in the later Montross show of 1912; his works were reproduced in *Camera Notes*. Mullins often worked, as here, at a very small scale. Although his style in *The Lifeboat* prefigures the later urban based modernism of Sheeler and Demuth, he is best known for his studies of nature.

WILLIAM JAMES MULLINS
Stieglitz Working in Gallery
Silver print, stamped
2¼ x 3¼
1912

Stieglitz did not allow informal photographs of himself in the '291' gallery, or the Little Galleries of the Photo-secession, as they were officially called, a problem which Mullins circumvented by use of a detective camera. The irony of the serious photographer caught with the instrument credited with opening the medium to amateurs is amusing. The edge of Mullins' button hole can be seen in the print.

THOMAS O'CONOR SLOANE, JR.
(1879-1963)
Mme. Sato
Gum platinum print
9¾ x 7¾
ca. 1908

Born in Brooklyn to Irish parents, Sloane's father was a scholar, scientist, and author, his mother the daughter of the Irish patriot John Mitchel. His brother married the daughter of Thomas Edison. Sloane had a lifelong interest in photography, becoming a professional after a brief teaching career in electrical engineering. He was best known for his portraits and his photographs of sculpture, interests which are evident in the present print. Sloane was a noted practitioner of the gum process, and was an associate of Stieglitz and Steichen, joining both the New York Camera Club and the Photo-secession.

ALICE BOUGHTON (1866-1943)
Portrait of Julia Ward Howe
Platinum print, signed
6⅝ x 6⅛
1908

This portrait of the American social reformer, lecturer, poet, and writer of the *Battle Hymn of the Republic* (1819-1910), is a variant of that included in Boughton's book *Photographing the Famous*, in which she describes her brief session with Mrs. Howe. The present print was Mrs. Howe's own copy. Boughton, who studied painting in Paris and Rome, was a studio assistant to Gertrude Kasebier shortly after the turn of the century. She became a member of the Photo-secession, where she exhibited with Yarnall Abbott and William Dyer in 1907, showing twenty-three prints. Her works were reproduced in *Camera Work*. She later had her own studio until 1931.[42]

WALTER R. LATIMER, SR. (1880-1924)
Ferryboat
Silver print
11 x 13½
ca. 1915

Little is known of Latimer, an engineer who took a year from his work to photograph, and to study privately with Clarence White. Most of his known work dates from this year, 1915. Latimer was married to the Pictorial photographer Blanche Hungerford. A sensibility which combines the minimalism of the Modern with the mysticism we associate with Whistler is strongly evident in this masterful print, which makes a strong visual statement from surprisingly simple materials.

DR. DRAHOMIR JOSEPH RUZICKA
(1870-1960)
Penn Station, New York
Silver print, signed
13½ x 10½
1919

Born in Bohemia, Ruzicka emigrated to the United States with his family at the age of six, living in the Midwest for five years before moving to New York. After receiving his degree in medicine, he returned to Europe to study with Wilhelm Roentgen, discoverer of the X-ray, and continued in general medical practice until 1922. An amateur photographer, Ruzicka exhibited in Europe and America after 1912, developing a wide reputation as an outstanding Pictorialist. Among his European followers was Josef Sudek, with whom he shared a

◆

circle of friends with photographic interests in Prague. He was well recognized in his own time, serving as President of the New York Camera Club, honorary fellow of the Royal Photographic Society in Great Britain, founding member of the Pictorial Photographers of America, and fellow of the Photographic Society of America.

HARRY C. RUBINCAM (1871-1940)
The Circus
Platinum print
13½ x 10
1902

Harry Cogswell Rubincam was born in Philadelphia and spent much of his life in the insurance business, first in New York and later, after 1896, for reasons of health, in Colorado. He was also briefly president of a small oil drilling corporation, in 1917 or 1918, and for the following six years attempted to make his livelihood at ranching.

Rubincam became interested in photography in the early 1890s; he is known to have been photographing at the World's Columbian Exposition in Chicago in 1892. He began as a self-taught amateur, but by the turn of the century was a regular columnist on photography, and both his work and his views on the subject were well known. Besides serving as president of both the Denver and the Colorado camera clubs, he became an associate of the Photo-secession in 1903 and exhibited in numerous salons and exhibitions, including three at the Photo secession Galleries. Other public displays of his work included exhibitions in London, St. Petersburg, and the Hague, as well as at the Carnegie Institute, the Corcoran Gallery, and other institutions in this country. Although his work was widely recognized and received numerous honors, Rubincam ceased photographing shortly after World War I.

Rubincam's circus series is an acknowledged benchmark in the development of modern photography. Its unassuming presence belies a careful approach to composition; its technical mastery is muted through delicate printing and the broad appeal of its vernacular subject. One need only note Rubincam's reduction of the dizzying visual complexity of the crowds and activity of the circus to a highly controlled tonal range which emphasizes the poles, seams, ropes and swings of the background, to see that he has transformed a thoroughly American scene into one of

modernist simplicity in which the disoriented lines take on a expressive identity of their own.[43]

LOUIS COMFORT TIFFANY (1848-1933)
Floral Decoration
Cyanotype, stamped on print, blindstamped on mount
9¼ x 7½
ca. 1890

Tiffany used images such as this in his studies for his paintings, glass, and design work. His use of the medium of photography, in combination with his association with other artists—including such major figures as Bonnard and Toulouse-Lautrec—and the public success of his work, make his photographs an interesting point of reference between photography and the more traditional arts. Because of its mounting and the manner in which it is stamped, *Floral Decoration* would seem to be a part of the extensive study collection assembled at Tiffany Studios, comprised of both the work of Tiffany and others. No doubt the artist was intrigued by the unusual linear quality of this plant, and wished to record it for future use. Tiffany also took more formal photographs, few of which are known. In addition, he is credited with early photographs of motion. The present print is characteristic of his search for beauty in the unusual, a quality found not only in his photographs but in his other work as well.[44]

STELLA SIMON (1878-1973)
Louis
Silver print
9¾ x 7½
1925

Simon, a native of Charleston, South Carolina, began as an amateur, taking up photography more seriously with the death of her husband in 1917. She studied with Clarence White, as well as working in filmmaking in Germany, before starting a commercial and advertising studio in New York in 1931. *Louis* is a portrait of her son.[45]

ALFRED CHENEY JOHNSTON (1884-1971)
Nude
Silver print, signed
13¼ x 10½
ca. 1922

Alfred Cheney Johnston was an amateur photographer and student of art at the National Academy of Design when he was hired by the flamboyant entrepreneur Florenz Ziegfeld in 1918 as official photog-

rapher for the Ziegfeld Follies. For Johnston, who insisted on being credited for his work, the confluence of expansion in commercial photography, publishing, and film, along with the change in national mood of the post-war twenties, led to immediate fame and a reputation which brought him considerable photographic work. He has been called "the photographer of the Jazz Age," and was one of the highest paid photographers of his era.

MAN RAY (EMMANUAL RADENSKI)
(1890-1976)
Inspiration
Hand mounted photogram
7 x 4½
ca. 1922

This unusually fluid photogram, mounted on colored paper, shows the links to painting and the art of his time felt by this important American modernist working in France. Although photograms had existed since the first years of the medium (and even in the work of Thomas Wedgwood and others, before), their starkness and childlike simplicity was attractive to modern artists questioning the boundaries of the arts. Photograms, or Rayographs as he called them—the direct impression of objects on light sensitive paper—form an important part of Man Ray's work, which was always exploratory and frequently outrageous.[46]

ANTON BRUEHL (1900-1982)
Still Life, Glass Spheres
Platinum print, signed and mounted
4¾ x 3¾
1925

Bruehl was born and raised in Australia, where he received a degree in electrical engineering. He emigratred to the United States in 1919. He worked as assistant to Jessie Tarbox Beals, and studied with Clarence White. He is known for his commercial work; among his clients were *Vogue*, *Vanity Fair*, and *House and Garden*, as well as a number of major corporations. He was an early practitioner of color photography. As one might suspect, *Still Life* is a Christmas card as well as a formal study.[47]

MAURICE BRATTER
Torso of Car
Silver print
8 x 10
ca. 1932

The relation of Bratter's work to his contemporaries and peers, in this case espe-

cially to well-known images of Strand and Stieglitz, is clear.

WILLIAM E. DASSONVILLE (1879-1957)
Ship's Deck
Silver print, signed
8 x 9¾
ca. 1926

Dassonville was a West Coast photographer active in the nineteen twenties and thirties. Along with Arnold Genthe, Anne Brigman and others, he was a member of the California Camera Club, a large organization centered in San Francisco whose members exhibited nationally and internationally. *Ship's Deck*, probably taken in San Francisco Bay, shows a refined, formalist sense of composition reminiscent of Sheeler. In its delicate variety of lines and planes, actuality and use of objects give way to a purely visual world in which relationships of repetition, line, and form take on a taut, philosophical resonance.

ALFRED CHENEY JOHNSTON
The Target
Color carbro print, signed
11¾ x 10½
ca. 1931

The three-color Carbro print was an early publishable form of color photography. Although a highly complicated process, public response to color in advertising justified its early commercial use. Successful practitioners of the process, among whom were not only Johnston but Outerbridge and the Bruehls, were being published in *Vogue* and other glossy magazines by the early 1930s. The process became obsolete with the introduction of new techniques which gained commercial success after the second World War. The imagery of *The Target*, clothed in the trappings and style of its time, is an apt embodiment of the advertising enterprise itself, which absorbed a significant portion of Johnston's professional time.

FRED PEEL (1884-1959)
The Reception Room
Bromide print, signed
7½ x 9⅝, hand cut border
1931

Peel was an amateur from Chester, Pennsylvania who enjoyed photography from early youth. Trained and employed as an engineer, he retired in 1925 to open a portrait studio. His technical innovations, especially in lighting, were widely admired. His studio included a complete machine shop with which he fabricated his own equipment; he wrote about his work and his experimental habits, and was depicted by others, in numerous articles. Among his professional peers, his artistic and technical control were a special point of admiration. His work was the center of the very popular Graflex exhibit at the Chicago Convention of the Photographers' Association of America in 1937. His varied works, ranging from Pictorialism to the hard edged style developed for advertising, were exhibited in numerous salons and exhibitions.

The Reception Room reveals the sort of technical and aesthetic innovation for which Peel was known. Beginning with a wide-angle lens placed at an unusual vantage point, he uses the distorted shapes of doors, windows and other familiar objects as abstract design elements, further emphasizing the experimental nature of his composition with a strongly defined but extremely idiosyncratic border. This image, which appeared with several others similar to it in an article on Peel in *The Camera* (US) in July 1931, and was exhibited numerous times, might be taken to exemplify the admiring but perhaps noncommital observation of one of Peel's commentators: "When an engineer enters the arts, things happen." It also echoes his adoption of the contemporary aesthetic attitude of which he himself spoke in a later article, in which he attributed a similarly abstract composition to an effort to adapt to visual work the principles of the swing or jazz music of his time.[48]

MAURICE BRATTER (1905-1986)
George Washington Bridge
Palladium print
10 x 8
ca. 1931

Bratter was born in Indianapolis, and moved to New York as a child. He was interested in photography at an early age, and was active in his high school camera club, entering photography contests at 13. He attended City College, and later the University of Michigan, from which he graduated in 1927. From 1928-31 he was assistant to Charles Sheeler; during the thirties he was represented by the precocious curator and art dealer Julien Levy, in New York, who admired his work, and exhibited him with Sheeler. In 1933 Bratter started his own photography business, Coma Labs. Besides portrait work, his clients included *The Herald Tribune*, *Vogue*, *Vanity Fair*, and other publications and businesses. He later left commercial photography, and turned to art and design.

With its aggressive forms, clean lines, and documentary overtones, this image might be taken as an icon of its era. Its sculptural qualities reveal the aspect of engineering and industry that inspired Calder and David Smith; its storytelling aspect (large and small; near and far; individual beams and long spans; discarded bolts still littering the fresh concrete) seems to capsulize progress and change.

MAURICE BRATTER
Roebling Steel
Palladium print
10 x 8
ca. 1930

Bratter's work shows some of the formality we might expect of an associate of Sheeler, but it has a distinct aesthetic tone of its own. While his three works shown here share certain formal values, each is quite different; together they reveal an artist of considerable talent. In *Roebling Steel*, the relationship of weight and light reminds us of a cathedral, and evokes the spirit of building. Bratter's ability to create a delicate composition from such massive materials helps to account for the moving quality of the image.

HAROLD HARVEY (1899-1971)
Cylinder
Experimental color process, signed
6¾ x 9
ca. 1935

Harvey was an inventor and innovator whose distinctive work has largely escaped later notice. His *Cylinder*, done in a medium of his own devising, and *Multiple: Woman*, a precursor to the later work of Warhol, place him among the most underrated American photographers of his time. An industrialist, Harvey's various photographic processes, such as the '777,' used by Barbara Morgan and others, were produced by his own company, Harvey Photochemicals. His photographic career began as a pictorialist; as a youth of only 17, he exhibited nine prints in the Camera Club of California's San Francisco Salon of 1916, the most of anyone in the exhibition. In Paris in the twenties he was associated with the modernist Man Ray; he was a member of the Circle of Confusion. He later worked as an advertising photographer. Both as an image and an object *Cylinder* is

◆

unusal. Its inherent modernism and simplicity appeal to the contemporary sensibility; its subtle coloring seems to draw us in to inspect it closely.[49]

W. GRANCEL FITZ
Glass Abstraction
Silver print, stamped
8 x 9¾
1929

The influence of Modernism, a new and important force in the visual art of Fitz's time, is apparent in this image done for Corning Glass.

HAROLD HARVEY
Multiple: Woman
Silver print
9 x 11
ca. 1935

The relation of *Multiple: Woman* to contemporary concerns in photography is difficult to miss. In its use of photography as reproductive mode, its subtle chiding of the social overtones of advertising, its commentary on repetition, and its seductive humor it is a thoroughly modern work that is well ahead of its time. Its apparent playfulness in contrast to its underlying seriousness as a work of art reflects Harvey's familiarity with Marcel Duchamp, Man Ray, and their circle.

W. GRANCEL FITZ (1894-1963)
The Ice Box
Silver print, signed
6 x 11½
ca. 1928

Grancel Fitz was one of the major advertising photographers of his day. Although he began as a Pictorialist, and was an amateur as late as 1920, by 1929 when he moved to New York, he was an accomplished professional with a highly polished style. Often his images, like *The Ice Box*, with its ice cube rainbow and preternatural gathering of easily spoiled foods, go beyond the credible to engage us through sheer invention. Others promulgate the new reality of Hollywood and the American dream of achievement and acquisition. In both cases, our historical view now often tinges what was then a clearly coded language of communication with aspects of the surreal.[50]

EDWARD WESTON (1886-1958)
Gourd
Silver print, signed, dated
9½ x 7½
1927

Weston, one of the acknowledged masters of twentieth century photography, was born near Chicago but lived much of his life in California. He spent an important period in the twenties in Mexico, where he lived and worked with the photographer Tina Modotti, and was a member of the circle of the painters Rivera, Siqueiros, and Orozco. Weston was a Pictorialist until his trip to New York in 1915, when he met Stieglitz, Strand, and Sheeler; later, with Willard Van Dyke and Ansel Adams, he helped to found the group f/64, whose commitment to a crisp, modernist print had a strong influence on American photography. Weston was the first photographer to receive a Guggenheim Foundation grant, which he used to travel and photograph in California and the West. In 1941, just before the American entrance to World War II, he photographed for a special edition of Whitman's *Leaves of Grass*. In 1946 Weston was honored with a major retrospective at the Museum of Modern Art, New York. Although suffering from Parkinson's Disease, he continued to photograph into the late forties. In 1950 he was given a retrospective in Paris. In 1952, he produced a *Fiftieth Anniversary Portfolio* with the help of his son Brett. In 1955, eight sets of 1000 prints of his best images were produced with Brett. He died in Carmel, California in 1958, in a house built by one of his sons. *Gourd* is an example of Weston's still lifes, the work for which he is perhaps best known to the public. The period of his work with objects—shells, fruits, vegetables, and wood, dates from the year of this print, which is an image less familiar than the frequently reproduced *Nautilus* or *Pepper* dating from the same time period.[51]

ALFRED CHENEY JOHNSTON
Albertina Vitak
Silver print, signed
13½ x 10½
ca. 1922

Albertina Vitak was a star dancer for Ziegfeld. Other Johnston subjects in New York, and later in Hollywood, included such well known entertainment figures as the Gish sisters, Dolores and Helen Costello, Mary Pickford, John Barrymore and Tyrone Power. In this photograph, Johnston's trademark use of drapery has been reduced to the most subtle level; his experience with glamour and the female figure is well apparent.[52]

ALFRED STIEGLITZ (1864-1946)
Equivalent
Silver print
3⅝ x 4⅝
1927

Alfred Stieglitz is the central figure in the photography of his era, and an important one in the world of modern painting as well. Born in Hoboken, New Jersey, where he spent his early years, he lived for an extended period in Europe before returning to the United States in 1890. Stieglitz' importance comes in part from his own work, and in part from his activity in criticism, organization, and exhibitions. Between 1894 and 1917 he was editor, in succession, of three important publications in photography on which he put the firm stamp of his taste and beliefs: *American Amateur Photographer, Camera Notes*, and *Camera Work*; the last is perhaps the best known of all photography publications. He was the founder of the Photo-secession, probably the most influential movement of its time, as well as of the three galleries on which he focused much of his exhibition work: the '291' gallery of the Photo-secession, An Intimate Place, and later An American Place. As an innovator, and supporter of the arts in modern America, Stieglitz has few peers. Of his *Equivalents* series Stieglitz said he intended to demonstrate through them the autonomy of the photograph, and hoped to remove photography from the psychologizing he felt it was subjected to by the criticism of the time. By choosing clouds he attempted to free himself from the confines of significant subject matter, allowing a viewer to concentrate simply on the photograph, which Stieglitz saw as a reflection, or equivalent, of his own deeper feelings.[53]

CHARLES SHEELER (1883-1965)
Portrait of Maurice Bratter
Silver print
9¾ x 7¾
ca. 1928

Sheeler's work in photography and painting is well known; he is among the most distinguished American artists of the first half of the twentieth century. Sheeler was from Philadelphia. He studied art, and began photographing professionally in 1912, concentrating on architectural photography. In 1913 he participated in the Armory Show, to which he contributed six paintings; he moved to New York in 1919, where he became a photographer for Condé Nast publications. Among his best-known

work at this time was his 1927 series on the Ford Motor Company plant at River Rouge, photographs whose combination of aesthetic and documentary interest exerted a strong influence over his young assistant pictured here. Sheeler continued to photograph through the late forties and into the fifties, returning again to painting in his later years.

W. GRANCEL FITZ
Gershwin's Hands
Silver print
5 x 7½
1929

These elegant photographs for the Steinway company evoke the age of which Gershwin is now a symbol, and the spirit in which his contemporary, Irving Berlin, had written in "I Love a Piano" (1915): "I know a fine way/to treat a Steinway."

W. GRANCEL FITZ
George Gershwin
Silver print, signed
9½ x 4¾
1929

BARON ADOLPH DE MEYER (1868-1946)
Portrait of Charlie Chaplin
Silver print, inscribed, signed
9⅜ x 7¼
1920

De Meyer, whose elusive early life is difficult to reconstruct, was raised in Germany, and moved from Dresden to England in 1896, where he became part of the fashionable circle of the Prince of Wales. From 1894 to 1912 he exhibited internationally, especially in London, Paris, and New York. De Meyer exhibited twice at the Photosecession galleries, and participated in Stieglitz' Albright Gallery exhibition of 1910. His work was twice reproduced extensively in *Camera Work* (seven gravures in *Camera Work* No. 24, and fourteen in No. 40). In 1914, at the outset of World War I, he moved with his wife to New York, where he became a photographer for Condé Nast publications, returning to Paris after the war. He returned again to the United States during the Second World War, settling finally in Hollywood.

De Meyer's life spans several important eras, and his career several distinct styles. Between the poles of his early Pictorialism and the later fashion work and portraits for which he is best known, we find a man versatile enough to move in the circles of the noble and wealthy, to survive the politi-

cal cataclysms of his time, and to continue to produce artistic work which was supported and collected by some of the most advanced patrons of photography, both commercial and private. His *Portrait of Charlie Chaplin* is a serious portrait of a comic actor, one of the great American public figures of the century. Signed by De Meyer and inscribed by Chaplin to Frank Crowninshield, editor of *Vanity Fair*, it is emblematic of the various worlds in which the photographer was at home: personal and public, artistic and commercial. The backlit profile and careful artificial lighting are characteristic of De Meyer's work.[54]

RAYMOND H. GEORG (1900-1958)
Portrait of Carl Sandburg
Silver print, signed
9½ x 7½
1922-3

Surprisingly, one of the most sensitive portraits of the American poet, folklorist, and biographer of Lincoln, Carl Sandburg, was done by a little known painter. Raymond Georg was born and raised in Springfield, Illinois, the son of a photographer. Completing a three year course in the arts in one year, 1918-19, he transferred from Illinois to the Yale School of Fine Arts, where he spent an additional two years. He then refused a scholarship to Paris to return to Springfield to operate his late father's studio, which he continued to do for several years. It was at this time that the portrait of Sandburg was taken. By the late twenties Georg had moved to New York to study and continue with his art, but he returned to Springfield in the mid-thirties, again working in a photographic studio, that of his brother Herbert. During World War II he did photographic work in Springfield for the Navy, later turning again to painting, and especially portraiture, until his death. Georg's portrait of Sandburg shows sensitivity to both subject and technique. In his print he has obtained a painterly, saturated quality devoid of excessive sentimentality which seems well-suited to the roughhewn features of the poet.

MARTIN BRUEHL (b. ca. 1900)
The Grain Elevators
Silver print, signed
8¼ x 6¼
ca. 1932

Martin Bruehl, who worked as a professional photographer, operated a successful commercial studio with his brother Anton.

His work was much praised by Steichen and others. *The Grain Elevators* shows Martin's strong sense of form, and that he was influenced by the social concerns and interest in vernacular subjects that motivated many photographers and other artists during the Depression.

ARTHUR ROTHSTEIN (1915-1985)
Dust Storm, Cimarron County
Silver print, stamped verso
7¾ x 7¾
1936

Rothstein's *Dust Storm* is one of the quintessential images of the Depression era. Its combination of physical chance in the momentary pose of the farmer, cultural circumstance in the family's battle with the times, and awe of nature in the storm itself make it one of the finest examples of photography's unique ability to frame American history. This early print came to the photoagency of Underwood and Underwood directly from the Farm Security Administration for whom it was taken, and captures exceptionally well the atmospheric quality that is such an important part of its subject. Rothstein went on to a long career in photojournalism and editing.

C. YARNALL ABBOTT (1870-1936)
Self-portrait
Platinum print
7 x 5
ca. 1902

Yarnall Abbott was a Philadelphia painter and photographer who was well known and exhibited widely during the first decade of this century. While he exhibited in the New York gallery of the Photo-secession, and his work was reproduced in their journal, he was not a member, wishing to remain above the politics of the arts. He participated in numerous other salons and exhibitions. An exhibition of 76 prints at the Photographic Society of Philadelphia in 1906, and 53 in a second exhibition there in 1911, serve to remind us that Abbott was one of the foremost photographers of his day. His *Self-portrait* shows an artist of great self-assurance, whose confidence in his ability allows him to compose an informal but serious portrait. The components of the delicately geometrical composition, including a model's platform, a tripod, a mirror, and the pipe smoking artist himself, framed in a dark doorway, raise associations which seem to make the *Self-portrait* an implicit homage to the arts.

◆

NOTES

Periodicals are listed in full; works listed in Bibliography are cited by author only.

1. Further treatment of the ideas expressed in this essay will be found in the author's articles in *The Print Collector's Newsletter*, Vol. XVI No. 5, Vol. XVII No. 1, Vol. XIX No. 2, and other published work.

2. The best available summary of the history of Brady's negatives and prints is found in the relevant entries in Vanderbilt. See especially Nos. 77-80.

3. Rev. J. Miller McKim in Mordell, p. 71.

4. The advent of the wet plate is treated in most thorough histories of the medium, among them Rosenblum, Gernsheim, and Newhall.

5. See Stapp, p. 46.

6. Forten and his peers are described in Bennett.

7. See for example the reproduction in Sobieszek and Appel; see also Pfister, pp. 107 ff.

8. See Pfister, pp. 259 ff., 301.

9. See Pfister, pp. 268 ff., and 359-60, and also Mordell.

10. Whittier, pp. 331-2. *The Branded Hand*, poem and image, are reproduced in Sobieszek and Appel.

11. See Pierce, and Thomas, p. 55.

12. See Floyd and Marion Rinhart, p. 380.

13. See Buckland, p. 255, and Newhall (*Essays and Images*), pp. 50 ff. The latter is drawn from Archer's first published announcement of the new technique. Archer also wrote a related monograph on this series of images.

14. Masury is noted in Taft; see also *Ballou's Pictorial*, Vol. 16 No. 13 (March 26, 1859), p. 205.

15. See "John B. Greene, an American Calotypist," Bruno Jammes, *History of Photography*, Vol. 5 No. 4 (1981), pp. 305 ff.

16. See Floyd and Marion Rinhart, p. 407.

17. Ibid., p. 402.

18. Although much has been written about Brady, the complexity of his large enterprise still leaves important matters of attribution and history to be resolved. A recent overview of Brady's work is to be found in Meredith.

19. See Miller, Vol. IX (original edition), p. 147. See also Apraxine, p. 445.

20. See Gardner.

21. See Miller, Vol. IX (original edition), pp. 265-8. An image from the council of war series appears in Newhall (*History*), p. 72.

22. E.L. Allen writing on a meeting of the Boston Photography Association in the *Philadelphia Photographer*, 1870, p. 46. See also Pierce.

23. See Bernard.

24. Russ Anderson in Alinder, p. 27.

25. Savage's railroad work is noted in the *Philadelphia Photographer*, 1876, p. 320.

26. The series from which this print comes is discussed in the *Philadelphia Photographer*, 1876, pp. 121 and 211.

27. There are a number of books and articles on O'Sullivan. An interesting recent study relevant to the works shown here is to be found in Dingus. The multi-volume reports of the United States Geological Survey, edited by Hayden and others, beginning in the 1870s, show the work of O'Sullivan and other survey photographers in their original context. A general introduction to nineteenth century photography in the Far West is Naef and Wood.

28. The most complete treatment of Watkins is Palmquist. The Columbia River series is reproduced in Alinder.

29. Reference to Butterfield's work at the Exposition is made in the *Philadelphia Photographer*, 1876, p. 196.

30. See Gould and Greffe, and Carnes.

31. Little has been written about Rau, who was the subject of a recent exhibition at The Museum of Modern Art, New York.

32. See *The National Cyclopaedia of American Biography*. A variant of this print was published in the *American Amateur Photographer*, February, 1891.

33. See Faber.

34. Five of Cox's portraits of Whitman appear in a recent edition of Whitman's classic *Specimen Days*, where they can be compared to other work of the time.

35. "Editorial Comment," *American Amateur Photographer*, March 1893, pp. 113-19. See also Naef (*Stieglitz*), which includes a number of Photo-secession members in the present selection.

36. Keiley's notice is "Mrs. Kasebier's Prints," *Camera Notes*, July, 1899, p. 34. The assertion of Mrs. Kasebier's superiority as a portraitist is also in *Camera Notes*: April 1900, p. 195. Six of her works appeared in the inaugural issue of *Camera Work* (No. 1), in 1903, and six in issue No. 10, in 1905. There are numerous accounts of her work.

37. The most complete study of Day is Jussim. He is mentioned in numerous general studies as well.

38. See for example *Photo-Era*, July, 1915, pp. 21 ff., and May 1919, p. 270; *The Photographic Journal*, April, 1918, pp. 171-2, and April 1919, pp. 179-80; *The American Magazine of Art*, October, 1919, pp. 172 ff.; *American Photography*, November, 1922, pp. 696 ff. An earlier article in

◆

The Independent (New York, October 17, 1907), written under a nom de plume, recounts Wentworth's experiences working on the railroads of the Southwest. See Naef (*Stieglitz*).

39. An informative short biography of Schaaf appears in the November 1981 issue of *The Wheelmen*, a periodical devoted to the heritage of bicycling.

40. See *Photo-Era*, Vol. 16 pp. 90-91.

41. Seeley's gravures are in *Camera Work* No. 15. See also Dimock, and Naef (*Stieglitz*).

42. Boughton, pp. 102-3. See also Naef (*Stieglitz*).

43. Rubincam wrote first for *Outdoor Life*, from 1901-4, and later for *Camera Work, The Photographer*, and others. A variant of the present print appeared as a gravure in *Camera Work*, and was called by Helmut Gernsheim, (*Creative Photography* p. 149), one of the "landmarks on the road to modern photography." See also Naef (*Stieglitz*).

44. See McBean, Chapter 16.

45. A brief sketch of Mrs. Simon appears in *Abel's Photographic Weekly*, 1932, p. 217.

46. Results of a recent resurgence in interest in Man Ray are his republished autobiography, a new biography by Neil Baldwin, and the catalog for a recent exhibition of his work, edited by Merry Foresta.

47. See Sobieszek (*The Art of Persuasion*), p. 193.

48. Peel's Graflex exhibit is described and pictured in *The Pocket Photo Monthly*, November, 1937, p. 608. His comment on jazz appears in "How I Crash Salons," *Good Photography*, Vol. 1 No. 3 (1939), pp. 36 ff. Two of his articles on lighting are to be found in *Camera Craft*, Vol. XL No. 19 (1933), pp. 491 ff., and Vol. XLI No. 6 (1934), pp. 280 ff. His popular image *The Flirt* is discussed in *The Camera* (UK), May, 1934, p. 512.

49. See Harvey's entry in Fielding.

50. Fitz has benefitted from a growth of interest in the art of advertising photography, and was the subject of a recent exhibition at The Museum of Modern Art, New York. Nye provides background and a critical treatment of images such as *The Ice Box*.

51. A number of books and articles by and about Weston describe his career and his work; he is discussed in most surveys. His daybooks provide a more intimate record of his creative life.

52. See Sobieszek (*The Art of Persuasion*), p. 195, and "The Amateur Who Glorified the Ziegfeld Girl," Arthur J. Busch, *Popular Photography*, March, 1951, pp. 58 ff.

53. Stieglitz' life and work have received wide comment. Certainly the most sumptuous recent presentation is Greenough and Hamilton, which accompanied the exhibition of his work at the National Gallery of Art, in Washington.

54. De Meyer figures in most major surveys of the field. A more personal sketch is to be found in Beaton and Buckland.

BIBLIOGRAPHY

James Alinder, ed., *Carleton E. Watkins: Photographs of the Columbia River and Oregon*, Friends of Photography and Weston Gallery, Carmel (CA), 1979.

Pierre Apraxine, *Photographs from the Collection of the Gilman Paper Company*, White Oaks Press, 1985.

Frederick Scott Archer, *Photographic Views of Kenilworth*, London, 1851.

Neil Baldwin, *Man Ray: American Artist*, Clarkson Potter, New York, 1988.

Cecil Beaton and Gail Buckland, *The Magic Image*, Little, Brown, Boston, 1975.

Lerone Bennett, Jr., *Pioneers in Protest*, Penguin Books, Baltimore, 1969.

Bruce Bernard, *Photodiscovery, Masterworks of Photography 1840-1940*, Harry N. Abrams, New York.

Alice Boughton, *Photographing the Famous*, Avondale Press, New York, 1928.

Gail Buckland, *First Photographs*, Macmillan Co., New York, 1980.

Cecil Carnes, *Jimmy Hare, News Photographer; Half a Century with a Camera*, MacMillan Co., NY, 1940.

George Dimock and Joanne Hardy, *Intimations and Imaginings: The Photographs of George H. Seeley*, The Berkshire Museum, Pittsfield (MA), 1986.

Rick Dingus, *The Photographic Artifacts of Timothy O'Sullivan*, University of New Mexico Press, Albuquerque, 1982.

John Faber, *Great News Photos and the Stories Behind Them*, Dover, New York, 1978.

Mantle Fielding, *Dictionary of American Painters, Sculptors, and Engravers*, Apollo, Poughkeepsie (NY), 1986.

Merry Foresta and others, *Perpetual Motif*, Abbeville Press, New York, 1988.

Alexander Gardner, *Photographic Sketchbook of the Civil War* (1866), Dover Books, New York, 1959.

Helmut Gernsheim, *Creative Photography: Aesthetic Trends, 1839-1960*, Boston Book and Art Shop, 1962.

Helmut and Alison Gernsheim, *The History of Photography: From the Camera Obscura to the Beginning of the Modern Era*, McGraw-Hill, New York, 1969.

Lewis L. Gould and Richard Greffe, *Photojournalist: The Career of Jimmy Hare*, University of Texas Press, Austin, 1977.

Sarah Greenough and Juan Hamilton, *Alfred Stieglitz, Photographs and Writings*, Callaway Editions, New York, 1983.

F.V. Hayden, Clarence King, and George M. Wheeler, eds., *United States Geological Survey*, U.S. Government Printing Office, Washington, 1870-1890.

Estelle Jussim, *Slave to Beauty: The Eccentric Life and Controversial Career of F. Holland Day*, David R. Godine, Boston, 1981.

Man Ray, *Self-portrait* (1963), New York Graphic Society, Boston.

Hugh F. McBean, *The Lost Treasures of Louis Comfort Tiffany*, Doubleday and Co., New York, 1980.

Roy Meredith, *Mathew Brady's Portrait of an Era*, W.W. Norton, New York, 1982.

Francis Trevelyan Miller, ed., *Photographic History of the Civil War* (1911), The Blue and Grey Press, 1987.

Albert Mordell, *Quaker Militant: John Greenleaf Whittier*, Houghton Mifflin Company, Boston, 1933.

Weston J. Naef, *The Collection of Alfred Stieglitz: Fifty Pioneers of Modern Photography*, Viking Press and The Metropolitan Museum of Art, New York, 1978.

Weston J. Naef and James N. Wood, *Era of Exploration: The Rise of Landscape Photography in the American West*, Albright-Knox Art Gallery and The Metropolitan Museum of Art; New York Graphic Society, Boston, 1975.

Beaumont Newhall, *Essays and Images*, The Museum of Modern Art, New York, 1980.

Beaumont Newhall, *The History of Photography, From 1839 to the Present Day*, The Museum of Modern Art, New York, 1964.

David Nye, *Image Worlds*, MIT Press, Cambridge (MA), 1985.

Peter E. Palmquist, *Carleton E. Watkins, Photographer of the American West*, Amon Carter Museum and University of New Mexico Press, Albuquerque, 1983.

Richard Pare, *Photography and Architecture: 1839-1939*, Callaway Editions, 1982.

Harold Francis Pfister, *Facing the Light: Historic American Portrait Daguerreotypes*, Smithsonian Institution Press with the National Portrait Gallery, Washington, 1978.

Sally Pierce, *Whipple and Black: Commercial Photographers in Boston*, Boston Athenaeum, Boston, 1987.

◆

Floyd and Marion Rinhart, *The American Daguerreotype*, University of Georgia Press, 1981.

Naomi Rosenblum, *A World History of Photography*, Abbeville Press, New York, 1984.

Robert Sobieszek, *The Art of Persuasion, A History of Advertising Photography*, Harry. N. Abrams, New York, 1988.

Robert Sobieszek and Odette M. Appel, *The Spirit of Fact: The Daguerreotypes of Southworth and Hawes*, David R. Godine with the International Museum of Photography, Boston, 1976.

William F. Stapp, *Robert Cornelius: Portraits from the Dawn of Photography*, Smithsonian Institution Press, Washington, D.C., 1983.

Robert Taft, *Photography and the American Scene: A Social History, 1839-1889* (1938), Dover Publications, New York, 1964.

D.B. Thomas, *The Science Museum Photography Collection*, Her Majesty's Stationery Office, London, 1969.

Paul Vanderbilt, *Guide to the Special Collections of Prints and Photographs in the Library of Congress*, Library of Congress, Washington, D.C., 1955.

Edward Weston, *The Daybooks of Edward Weston*, Aperture, Millerton (NY), 1973.

Walt Whitman, *Specimen Days*, David R. Godine, Boston, 1971.

John Greenleaf Whittier, *The Complete Poetical Works of John Greenleaf Whittier*, Houghton Mifflin Company, Boston, 1894.

◆

Abbott, C. Yarnall, 13, 132, 136
 Self-portrait, 122,136
abolitionism, 7, 13-14, 123-4
Adams, Ansel, 135
advertising, 20, 128, 134, 135
aerial views; flight, 128,129
Albright Gallery, exhibition, 1910,
 130, 131, 132, 136
albumen print, 15ff
amateur movement, 18, 132
American Amateur Photographer,
 130, 135
Anson, Rufus
 *General Ethan Allen Hitchock, 14,
 30*, 124
Anthony, E. & H. T. Co., 16, 128
Archer, Frederick Scott, 13, 15, 124
 Self-portrait, Kenilworth, 14, *31*
Armory Show, 135
Bancroft, George Harding, 15, 125
Barker, George, 17, 128
 Niagra in Winter, *58*, 128
Barnard, George, 16, 126
Barnum, P.T., 10
Battle Hymn of the Republic, The, 132
Beals, Jessie Tarbox, 133
Beardsley, Aubrey, 130
Beecher, Henry Ward, 10, 123
Bell, Alexander Graham, 129
Bell, Curtis, American Pictorialists,
 American Salon, 131
Bell, Louise, 128
Bell, William, 16, 126, 127, 128
 *Looking South into the Grand
 Canyon of the Colorado River at
 Sheavwitz Crossing, 52*, 127
 *Private George Ruoss, Wounded
 Near Petersburg, March 31, 1865,
 43*, 126
Berlin, Irving, 135
Bierce, Ambrose, 17
Bisson Frères, 124
Black, James Wallace, 126, 128
 *Edward Everett Hale and Son,
 46*, 126
Black, Jeremiah, 15, 125
Blake, Francis, 129
 Man on Bicycle, 67, 129
 Pigeons in Flight, 66, 129
Blanquart-Evrard, 125
Boker, George H., 15, 125
Bonnard, Pierre, 133

Boughton, Alice, 21, 132
 Julia Ward Howe, 21, *93*, 132
Brady, Mathew, 11, 15, 16, 19, 125,
 126,127
 Jeremiah Black, Statesman, 37, 125
 Literary Group, 38, 125
 *71st New York State Militia,
 The Naval Yard, Washington,
 41*, 126
Bratter, Maurice, 17, 20, 134, 135
 George Washington Bridge, 106,
 134
 Roebling Steel, 107, 134
 Torso of Car, 102, 133
bridges, 20, 126, 127
Brigman, Anne, 134
Bruehl, Anton, 20, 133, 134, 136
 Still Life, Glass Spheres, 101, 133
Bruehl, Martin, 17, 20, 134, 136
 The Grain Elevators, 120, 136
Bryant, William Cullen, 15, 125
Buchanan, James, 15, 125
Bull Run, battle monuments, 126
Burleigh, Charles Calistus, 14, 123
Burroughs, John, 131
Butterfield, David W., 17, 128
 Dover Neck, New Hampshire, 60,
 128
 *Mills of the Winona Paper
 Company, Chicopee,
 Massachusetts, 61*, 128
Byron, Joseph, 128
Calder, Alexander, 134
camera clubs of Boston, New York,
 Philadelphia, California et al.,
 129ff
calotype, 15, 125
Camera Notes, 132, 135
Camera Work, 130ff, 135
carte de visite; cabinet card; albums,
 15
Centennial Exposition, Philadelphia,
 128
Century Magazine, 129
Chaplin, Charlie, 136
Chislett, John, 131
 Trees, 86, 131
Circle of Confusion, 134
Civil War, 7, 10, 15-16, 19, 39-45,
 125-127
Coburn, Alvin Langdon, 19, 130
 The Mill At Ipswich, 19, *76*, 130

Collier's magazine, 128, 129
collodion process, 15-18, 124
color photography, 133, 134
Columbia River, 127
Condé Nast publications, 135, 136
Cornelius, Robert, 125
Cox, George C., 129
 Portrait of Edward MacDowe
 129
Crowninshield, Frank, 136
Crystal Palace (Great Exhibition)
 125
cyanotype, 19, 130, 133
daguerreotype, 13-14, 16, 22-30, 1
Dassonville, William E., 134
 Ship's Deck, 103, 134
Davis, Dwight A., 131, 132
 Little Girl with Parasol, 84, 1
 A Pool in the Woods, 87, 132
Day, F. Holland, 130
 Pepita, 78, 130
De Meyer, Baron Adolph, 136
 Portrait of Charlie Chaplin, 1
 136
democracy, 11
Demuth, Charles, 132
detective camera, 132
documentary photography, 17, 2(
 126-129, 134, 136
Duchamp, Marcel, 135
Dyer, William, 132
Eakins, Thomas, 129
Edison, Thomas, 132
Emerson, Ralph Waldo, 10
Everett, Edward, 126
Farm Security Administration (I
 136
Fitz, Grancel, 20, 135, 136
 George Gershwin, 117, 136
 Gershwin's Hands, 116, 136
 Glass Abstraction, 109, 135
 The Ice Box, 111, 135
Ford, James, 127
Forten, James, 14
Fowx, Egbert Guy, 125
 *44th New York Encampment
 Christmas Night, 39*, 125
f/64, 135
Fremont, John C., 15, 123, 125
Gardner, Alexander, 15, 16, 19, 1
 126, 127
 Camp Houses, 40, 125

◆

*Portrait of Andrew Johnson,
 Seventeenth President of the
 United States, 45,* 126
*While Judge Olin Was Delivering
 the Address, 44,* 126
*Railroad Station, Wamego,
 Kansas, 48,* 126
*Self-portrait Along the Route of the
 Union Pacific Railroad, 49,* 127
*Photographic Sketchbook of the
 Civil War,* 126, 127
Garrison, William Lloyd; *The
 Liberator,* 14, 123
Genthe, Arnold, 131, 134
Georg, Herbert, 136
Georg, Raymond H., 21, 136
 Portrait of Carl Sandburg, 119, 136
Gershwin, George, 20, 136
Gilbert, C. M., 129
 Chat-about-the-Hand (Joe Jefferson
 and Helen Keller), *70,* 129
Glasier, Fred W., 128
 A Stellar Group, 63, 128
Grand Canyon, 52, 127
Greeley, Horace, 10
Greene, John B.
Algeria, 34
gum process, 19, 130ff
Hale, Edward Everett, 15, 126
Hare, James H. (Jimmy), 20, 128, 129
 *First Aerial Photo of New York,
 from Balloon, 62,* 128
 *Orville and Wilbur Wright with
 Plane, 68,* 129
Harper's Weekly, 126
Harvey, Harold, 20, 134
 Cylinder, 108, 134
 Multiple: Woman, 110, 134
Hayden, F. V., 127
Hermann, Frank, 130
Hine, Lewis, 19
Hitchcock, General Ethan Allen, 14,
 124
Hogg, Jabez, 124
Hollywood, stage and film stars as
 subjects, 135, 136
 influence of, 135, 136
House and Garden, 133
Howe, Julia Ward, 123
Hungerford, Blanche, 132
Illustrated American (New York), 128
Impressionism, photographic, 131
industrial subjects, 20, 134
Ivory soap, 128
Jackson, William Henry, 17, 127, 131
 *Gunnison Butte, The Green River,
 Utah, 55,* 127
Jefferson, Joe, 129

Johnson, Andrew, 15, 126
Johnson, Clifton, 19, 131
 John Burroughs, 81, 131
Johnston, Alfred Cheney, 20, 133,
 134, 135
 Albertina Vitak, 113, 135
 Nude, 99, 133
 The Target, 104, 134
Kasebier, Gertrude, 13, 18, 130, 131
 Happy Days, 82, 131
 The Red Man, 13, 80, 131
 Summertime, 83, 131
 The Wedding, 75, 130
 The Manger, 130
Keiley, Joseph, 130
Keller, Helen, 129
Kensett, John Frederick, 124
King, Clarence; 40th Parellel Survey,
 127
Langenheim, Frederick and William,
 123
 Charles Calistus Burleigh, 25, 123
 John Greenleaf Whittier, 26, 123
lapel button, 124
Latimer, Walter R. Sr., 19, 132
 Ferryboat, 19, 94, 132
Levy, Julien, 134
Lincoln, Abraham, 11, 125, 126, 136
Linked Ring, 130
Loring, Charles Greely, 13, 124
Lovejoy, Dr. Rupert S., 130
 Finale, 77, 130
May Ray, 133, 134
 Inspiration, 100, 133
Masury, Samuel, 7, 16
 *Landscape, Pride's Crossing, 13,
 33*
 On the Loring Estate, 13, 32
Meade, Richard and Henry, 125
 *James Buchanan, Fifteenth
 President of the United States,
 36,* 125
Meserve, Frederick, 129
Mexico, artists of, 135
Mississippi River, 126, 127
Missouri River, 126
Modernism, 20, 135
Modotti, Tina, 135
Montross show, 130, 131, 132
Morgan, Barbara, 134
Morse, Samuel F. B., 125
Morris, William, 130
Mount, William Sidney, 124
Mullins, William James, 132
 The Lifeboat, 90, 132
 *Stieglitz Working in Gallery, 13,
 91,* 132
Muybridge, Eadweard, 129

National Academy of Design, 135
New York Herald Tribune, 134
Niagra, 123, 128
O'Sullivan, Timothy, 15, 16, 19, 126, 127
 *Black Canyon, Arizona, Wheeler
 Survey, 53,* 127
 *Wagon in Desert, King Survey,
 Nevada, 56,* 127-8
Outerbridge, Paul, 134
Peel, Fred, 20, 134
 The Reception Room, 105, 134
Pennsylvania Freeman, 14, 123
Philadelphia Photographer, 126
photo agencies, 16, 129
Photo-Era, 130, 131, 132
photogram, 133
Photographers Association of
 America, 134
*Photographic History of the Civil
 War,* 125
Photographic Journal of America,
 131
Photo-secession, 130ff, 135
photojournalism, 17, 19-20, 128
pictorialism, 130ff
Pictorial Photographers of America,
 130, 131, 133
platinum, platinotype, 19, 129ff
Plumbe, John, 124
Polk, James K., 125
portraits, 13-16, 20, 126, 130, 132, 134,
 135, 136
Post, William B. 130, 132
 The Critic (Alfred Stieglitz and
 Frank Hermann), *74,* 130
 Intervale, Winter, 89, 132
railroads, 10, 126, 127, 128
Rau, William H., 17, 128
 Penn Haven Junction, 64, 128
Riis, Jacob, 19
Roentgen, Wilhelm, 132
Root, Marcus, 125
Root, Samuel, 125
 *John C. Fremont, "The Pathfinder,"
 35,* 125
Rosetti, D. G., 126
Rothstein, Arthur, 13, 17, 136
 *Dust Storm, Cimarron County,
 121,* 136
Royal Photographic Society, 124, 129,
 130, 133
Rubincam, Henry C., 133
 The Circus, 96, 133
Ruskin, John, 126
Russell, A. J., 126
Russo-Japanese War, 128
Ruzicka, Dr. D. J., 132
 Penn Station, New York, 95, 132

◆

142

salt prints, 15, 124-125
Sandburg, Carl, 136
Sander, August, 128
Savage, Charles, 17, 127
 Dodge's Bluff, Canyon of Grand
 River, Rio Grande Western
 Railroad, 54, 127
Saxton, Joseph, 123
Schaaf, Albert Ernest, 131
 The Race, 85, 131
 The Greenwich Reach, 131
Scheffer, Ary, 123
Seeley, George H., 131, 132
 Landscape, 88, 132
 Early Morning, 132
Sheeler, Charles, 20, 132, 133, 134, 135
 Portrait of Maurice Bratter, 115,
 135
Simon, Stella, 133
 Louis, 98, 133
Sloane, Thomas O'Conor, Jr., 132
 Mme. Sato, 92, 132
Smith, David, 134
Southworth, Albert Sands, and Hawes,
 Josiah Johnson, 123, 126
 Black and White Hands on a
 Prayer Book, 27, 123-4
 Harriet Beecher Stowe, 12, 24, 123
 The Branded Hand, 124
Spanish American War, 128
Spencer, Ema, 18, 19, 130
 Girl at Table with Peaches, 73, 130
Steichen, Edward, 130, 132
stereoscope, 15
Stieglitz, Alfred, 130ff, 135
 Equivalent, 114, 135
Stillman, William James, 126
Stowe, Harriet Beecher, 7, 12, 143

Uncle Tom's Cabin, 14, 143
Strand, Paul, 134, 135
Stuart, Gilbert, 11
Sudek, Josef, 132
Sully, Thomas, 125
surveys, United States, 127, 129
symbolism, political, 124
Taylor, Bayard, 15, 17, 125
Thoreau, Henry, 10, 131
Tiffany, Louis Comfort, 19, 133
 Floral Decoration, 97, 133
tintype, 128
Toulouse-Lautrec, Henri de, 133
travel photography, expeditionary,
 foreign, 125, 128
Twain, Mark, 17, 130
'291' Gallery, 130ff, 135
Underwood, William Orison, 19, 130
 The Mill at Ipswich, 19, *76,* 130
Underwood and Underwood, 129, 136
 Society Ladies at Annual Horse
 Show, Newport, R.I., 65, 129
unknown photographer,
 Aerial Photographer and Plane,
 69, 129
 Bridge Across the Mississippi
 River, 50, 127
 Child with American Flag, 29, 124
 City View, 22, 123
 Divers, Kansas City Bridge, 47, 126
 James Forten, 23, 123
 Ivory Soap, 59, 128
Vance, Robert, 127
van Dyke, Willard, 135
Vanity Fair, 133, 134, 136
Vogue, 133, 134
Walker, Lewis Emory, 126, 127
 Man and Mortar, 42, 126

Warhol, Andy, 134
Washington, George, 7, 11
Watkins, Carleton, 17, 127, 128
 Cape Horn, Near Celilo, 51, 127
 Oregon Steam Navigation
 Company Works, Dalles City,
 Columbia River, 57, 128
Wedgwood, Thomas, 133
Wentworth, Bertram H., 131
 Cholla, 79, 131
Far West, 10, 16ff, 127, 128
Weston, Brett, 135
Weston, Edward, 17, 20, 135
 Gourd, 112, 135
 Nautilus, 135
 Pepper, 135
wet plate process, 15-18, 123-128
Wheeler, Gen. George M.; Survey
 West of 100th Meridian, 127
Whipple, John Adams, 124, 126
 The Moon, August 6, 1851, 28, 124
Whistler, James A. M., 129, 132
White, Clarence, 130, 131, 132, 133
Whitman, Walt, 10, 129, 135
Whittier, John Greenleaf, 7, 123
 "On a Prayer Book"; "The Branded
 Hand," 123
Willis, William, 19, 129
 Cottage Scene, 19, *72,* 129
World War I, 7, 128, 133, 136
World War II, 134, 136
World's Columbian Exposition, 133
Wright, Orville and Wilbur, 68, 129
X-ray, 132
Yosemite, 127
Ziegfeld, Florenz, 135

◆